Cool Restaurants Vienna

teNeues

Imprint

Editor: Joachim Fischer
Editorial coordination: Sabina Marreiros
Photos (location): Roland Bauer (Artner, Babu, Bar Italia Lounge, Buddha Club, Café Berg, Café-Restaurant Una, Cantinetta Antinori, Collio, Do & Co Albertina, Gaumenspiel, Halle, Indochine21, Kim kocht, Loos American Bar, MAK Café, Meinl am Graben, Mole West, Onyx Bar, Oswald & Kalb Restaurant, Palmenhaus, Shambala, Wrenkh Restaurant & Bar) Peter Burgstaller (Brunners food), Courtesy Ruben's Brasserie (Ruben's Brasserie), Ulrike Holsten (Wrenkh Restaurant & Bar), Alexander Koller (Yellow), Rupert Steiner (Fabios, Yume)
Introduction: Joachim Fischer
Layout: Thomas Hausberg
Imaging & Pre-press: Jan Hausberg
Map: go4media. – Verlagsbüro, Stuttgart
Translations: SAW Communications, Dr. Sabine A. Werner, Mainz
Dr. Suzanne Kirkbright (English), Dominique Le Pluart (French)
Gemma Correa-Buján (Spanish), Elena Nobilini (Italian)
Nina Hausberg (English / recipes)

Produced by fusion publishing GmbH
www.fusion-publishing.com

Published by teNeues Publishing Group

teNeues Publishing Company
16 West 22nd Street, New York, NY 10010, USA
Tel.: 001-212-627-9090, Fax: 001-212-627-9511

teNeues Book Division
Kaistraße 18, 40221 Düsseldorf, Germany
Tel.: 0049-(0)211-994597-0, Fax: 0049-(0)211-994597-40

teNeues Publishing UK Ltd.
P.O. Box 402, West Byfleet, KT14 7ZF, Great Britain
Tel.: 0044-1932-403509, Fax: 0044-1932-403514

teNeues France S.A.R.L.
4, rue de Valence, 75005 Paris, France
Tel.: 0033-1-55766205, Fax: 0033-1-55766419

www.teneues.com

ISBN: 3-8327-9020-9

© 2005 teNeues Verlag GmbH + Co. KG, Kempen

Printed in Germany

Bibliographic information published by Die Deutsche Bibliothek. Die Deutsche Bibliothek lists this publication in the Deutsche Nationalbibliografie; detailed bibliographic data is available in the Internet at http://dnb.ddb.de.

Contents Page

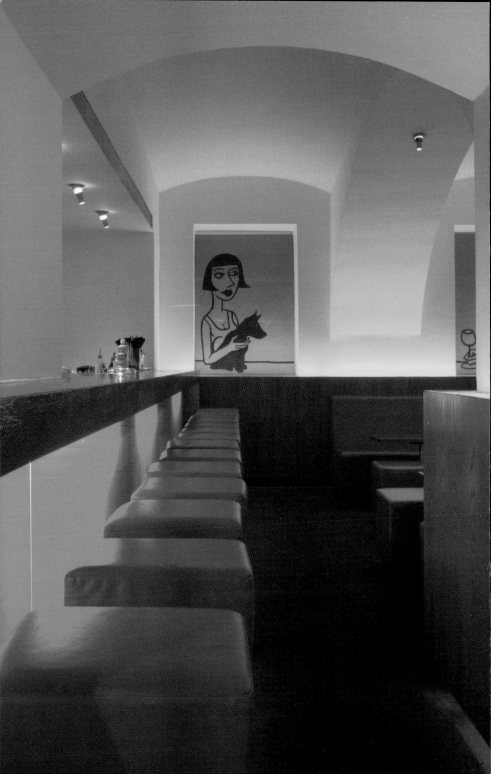

Einleitung

Wien, die Sehnsuchtsstadt der k.u.k.-Monarchie, glänzt wieder als Metropole an der Donau. Die Stadt ist im Aufbruch, spannend und voller Entdeckungen, sie präsentiert sich bei all ihren Traditionen lebendig, aufregend und wandlungsfähig. Dabei riskiert man, nicht ganz so hip wie andere Metropolen zu sein. Dennoch essen die Wiener beileibe nicht nur die gleichnamigen Schnitzel. Die geografische Lage zwischen West- und Osteuropa, Kaffee und Gewürze prägen seit eh und je die Wiener Gastronomie.

Neben der vielfältigen Küche versuchen die Gastronomen mit besonderem Interieur kultivierte kosmopolitische Gäste anzusprechen. So haben es seit Adolf Loos' American Bar heimische und internationale Architekten und Designer verstanden, fremde und exotische mit regionalen Einflüssen zu mischen, wie die modernen Restaurants von BEHF-Architekten oder die Dependance der Pariser Buddha Bar zeigen. Den besonderen Reiz macht vielfach das Wechselspiel zeitgemäßer Einrichtungen mit den die Lokale beheimatenden historischen Gebäuden aus. Dies schlägt sich in der typischen Wiener Lokalszene wie den schicken Restaurants am Graben, dem Beisl in der Bäckerstraße, dem legendären Bermudadreieck, den neuen Lokalen im MuseumsQuartier und den Bars und Restaurants am Naschmarkt nieder.

Weit über die bekannte Tradition der Kaffeehäuser und Restaurants hinaus, gelingt es den Designern dabei, die bestehenden Grenzen in der Gastronomie zu überschreiten. Sie entwerfen Interieurs, die sowohl tagsüber als auch nachts genutzt werden können. So werden Cafés zu Bars und Lounges und Restaurants zu variablen Räumlichkeiten, in denen man unter einem Dach essen, trinken und tanzen kann. Es gibt ebenso viele Designer, die klassische, dauerhafte Einrichtungen entwerfen, wie solche, die phantasievolle Räumlichkeiten nur für den Moment schaffen.

Wie auch immer, unser besonderes Augenmerk und unser Applaus gilt all jenen, die es verstehen, Moderne mit Tradition zu einer ganz neuen Komposition aus Design, Architektur und leiblichen Genüssen zu verknüpfen.

<div align="right">Joachim Fischer</div>

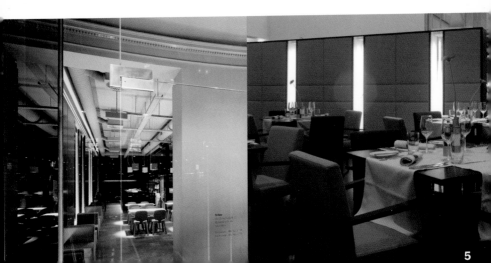

Introduction

Vienna, city of dreams for the royal imperial monarchy, is once again a glittering metropolis on the Danube. The city is rejuvenating, full of adventure and discoveries and, for all its traditions it presents itself as lively, exciting and ready for change. That means risking not being quite so hip as other metropolises. But by no means do the Viennese only eat the famous Schnitzel named after them. The geographical location between western and eastern Europe, coffee and spices, have influenced Viennese gastronomy since records began.

In addition to a diverse cuisine, restaurateurs try to appeal to cultivated and cosmopolitan guests with distinctive interiors. Ever since Adolf Loos' American Bar, this is how domestic and international architects and designers have appreciated how to blend foreign and exotic with regional influences, as shown by BEHF architects' modern restaurants or the branch of the Parisian Buddha Bar. A special attraction is the manifold interplay of contemporary furnishing with historical buildings. This is apparent in the typical Viennese restaurant scene, such as the classy restaurants at the Graben, the Beisl (tavern) in Bäckerstraße, the legendary Bermuda Triangle, the new restaurants in the MuseumsQuartier and bars and restaurants at the Naschmarkt.

The designers have been successful in these cases in overstepping existing limits in the restaurant trade and going far beyond the well-known coffee house tradition. They design interiors, which can be used at day and night-time. This is how cafés are turned into bars; and lounges and restaurants become flexible spaces, where guests can eat, drink and dance under the same roof. There are just as many designers, who draw up classical and lasting interiors, as others, who create imaginative spaces purely to fit the moment.

Whatever the case, our particular awareness and applause goes to all, who know how to combine modernity and tradition to form an entirely new composition of design, architecture and physical pleasures.

Joachim Fischer

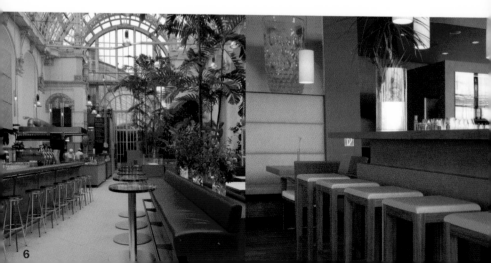

Introduction

Vienne, la ville nostalgique de la monarchie royale et impériale est redevenue la grande métropole du Danube. Elle est en plein essor, palpite et appelle à la découverte. Riche en traditions, cela ne l'empêche pas d'être bouillonnante et tournée vers l'avenir. Même si elle n'est peut-être pas aussi branchée que certaines métropoles, on n'y mange pas que des escalopes qui portent son nom (Wiener Schnitzel). Dans cette ville située entre l'Europe occidentale et l'Europe orientale, le café et les épices ont toujours été la marque de la gastronomie viennoise.

Pour attirer les gourmets du monde entier, les restaurateurs proposent une cuisine très diversifiée et attachent une grande importance au cadre. Depuis l'ouverture de l'American Bar d'Adolf Loos, architectes et designers nationaux et internationaux maîtrisent le mélange des influences étrangères et exotiques avec les particularités régionales. Les restaurants du cabinet d'architectes BEHF ou la dépendance de la Buddha Bar à Paris en sont des exemples. L'attrait particulier réside souvent dans le jeu d'alternance entre décor moderne et murs historiques.

Ce style s'est développé dans les quartiers et les lieux de Vienne où l'on aime sortir : le Graben où il y a tous les beaux restaurants, le « Beisl » (taverne) dans la Bäckerstraße, le légendaire Triangle des Bermudes, les nouveaux établissements du MuseumsQuartier, ainsi que les bars et restaurants du Naschmarkt.

Bien au-delà de la fameuse tradition des cafés et des restaurants, les designers ont réussi à dépasser les limites de la gastronomie locale et inventent des intérieurs qui conviennent autant pour les sorties de jour que de nuit. Ainsi les cafés se transforment en bars, et les lounges et restaurants deviennent des espaces modulables où l'on peut manger, boire et danser sous un même toit. Les créateurs d'intérieurs classiques et durables sont aussi nombreux que ceux qui préfèrent concevoir des décors fantastiques mais éphémères.

Quoi qu'il en soit, nous apprécions et encourageons tous ceux qui ont l'art de combiner le moderne et la tradition et de recomposer des ensembles inédits intégrant le design, l'architecture et le plaisir des sens.

<div align="right">Joachim Fischer</div>

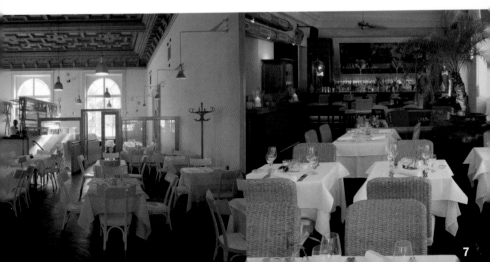

Introducción

Viena, la ciudad de los anhelos de la monarquía imperial y real brilla de nuevo como metrópoli en el Danubio. La ciudad está en resurgimiento, emocionante y llena de descubrimientos y se presenta, en toda su tradición, de forma vital, excitante y versátil. En ello se arriesga a no ser tan de moda como otras metrópolis. No obstante, los vieneses de ninguna manera comen solamente los escalopes del mismo nombre. La situación geográfica entre Europa del Este y del Oeste, el café y las especias caracterizan desde siempre la gastronomía vienesa.

Junto a la variada cocina los gastrónomos intentan agradar a los cultivados clientes cosmopolitas con interiores especiales. Así, desde el American Bar de Adolf Loos, los arquitectos y diseñadores locales e internacionales han sabido mezclar las influencias extranjeras y exóticas con las regionales como lo muestran los restaurantes modernos de la oficina de arquitectos BEHF o las dependencias del Buddha Bar parisino. El especial atractivo lo conforma a menudo la interacción de una decoración actual con los edificios históricos donde los locales están establecidos. Esto se refleja en la típica escena de locales vienesa como son los elegantes restaurantes en el Graben, el Beisl (La Taberna) en la Bäckerstraße, el legendario Triángulo de las Bermudas, los nuevos locales en el MuseumsQuartier y los bares y restaurantes en el Naschmarkt.

Al mismo tiempo, los diseñadores consiguen sobrepasar las fronteras existentes en la gastronomía más allá de la conocida tradición de los cafés y restaurantes. Proyectan interiores que pueden ser utilizados tanto durante el día como la noche. Así, los cafés se convierten en bares y los lounges y restaurantes en locales variables en los que se puede comer, beber y bailar bajo un techo. Existen muchos diseñadores que proyectan diseños clásicos y duraderos e igualmente aquellos que crean locales llenos de fantasía sólo para el momento.

Sea como sea, nuestra atención especial y nuestro aplauso están dirigidos a aquellos que saben enlazar lo moderno con la tradición en una composición de diseño, arquitectura y deleites gastronómicos totalmente nueva.

Joachim Fischer

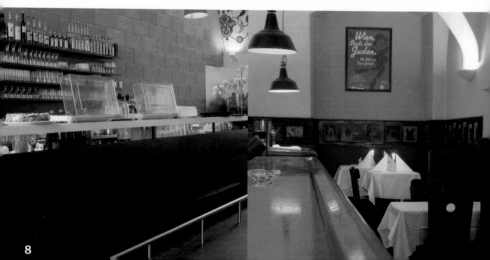

Introduzione

Vienna, la città nostalgica della Monarchia imperial-regia, è tornata a splendere come metropoli sul Danubio. La città si sta risvegliando, affascinante e tutta da scoprire, e si presenta, pur con tutte le sue tradizioni, vitale, emozionante e poliedrica. E il rischio è quello di non apparire così trendy come altre metropoli. Eppure i viennesi non mangiano affatto solamente le omonime cotolette. La posizione geografica tra l'Europa occidentale e orientale, il caffè e le spezie influenzano da sempre la gastronomia viennese.

Oltre che con la svariata cucina, i gastronomi cercano di deliziare i raffinati clienti cosmopoliti con interni particolari. E così, a partire dall'American Bar di Adolf Loos, architetti e designer nazionali e internazionali hanno saputo unire gli influssi stranieri ed esotici a quelli regionali, come dimostrano i moderni ristoranti ideati da architetti BEHF o la dependance del Buddha Bar di Parigi. A creare questo fascino particolare è spesso il gioco di alternanza tra arredamenti moderni e edifici storici che ospitano i locali. Ciò trova espressione nella tipica scena dei locali viennesi, per esempio nei ristoranti chic del Graben, nel Beisl (osteria) nella Bäckerstraße, nel leggendario Triangolo delle Bermuda, nei nuovi locali del MuseumsQuartier e nelle osterie e nei ristoranti del Naschmarkt.

I designer riescono a superare i limiti della scena gastronomica, spingendosi al di là della ben nota tradizione dei caffè e dei ristoranti e progettando interni utilizzabili tanto di giorno quanto di notte. Ecco che i caffè si trasformano in osterie e locali lounge e i ristoranti in ambienti versatili in cui mangiare, bere e ballare.

Ci sono designer che progettano arredamenti classici e duraturi e altrettanti che creano locali fantasiosi e ideati solo per il momento.

Comunque sia, la nostra attenzione particolare e il nostro applauso si rivolgono a tutti coloro che sanno combinare modernità e tradizione, dando forma ad una composizione completamente nuova fatta di design, architettura e piaceri del palato.

Joachim Fischer

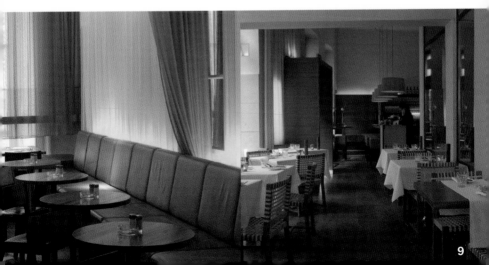

Artner

Design: Hans Pimpel | Chef: Markus Waldhäusl

Floragasse 6 | 1040 Wien | 4. Bezirk
Phone: +43 1 503 50 33
www.artner.co.at | restaurant@artner.co.at
Subway: Taubstummengasse
Opening hours: Mon–Fri 11 am to 1 am, Sat–Sun 6 pm to 1 am
Average price: € 14–20
Cuisine: Creative Austrian
Special features: Own winery, Gault Millau prized

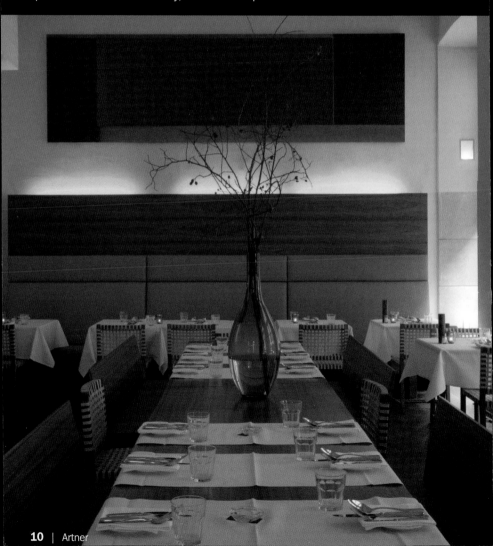

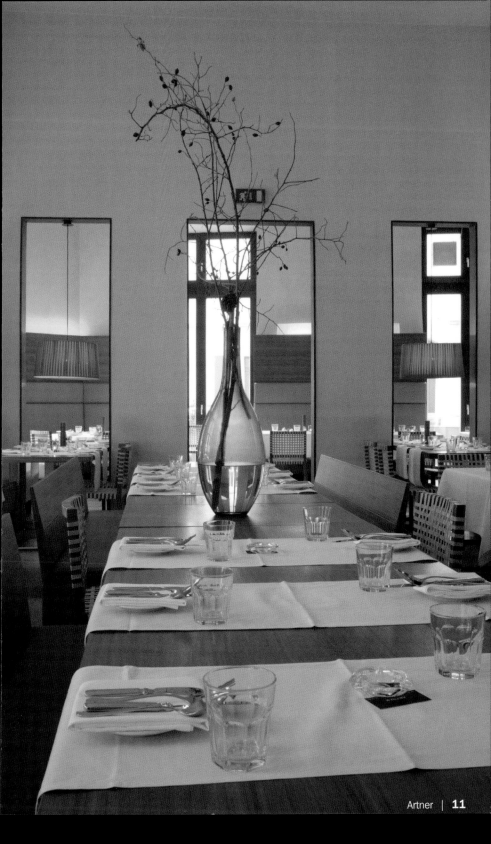

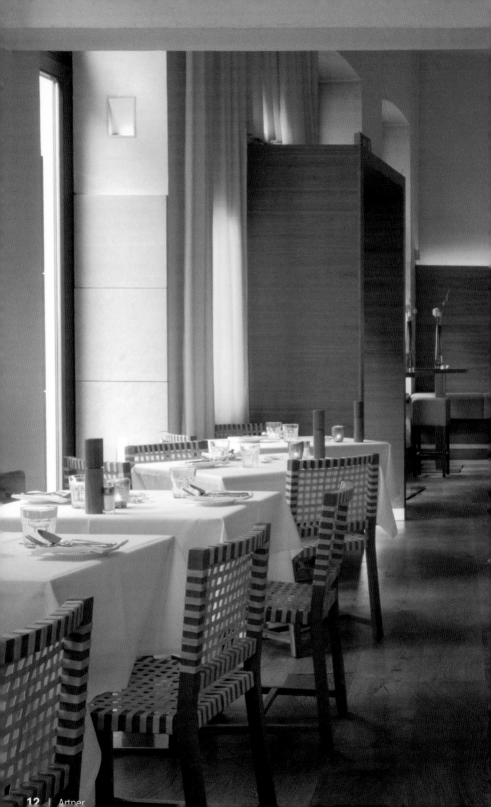

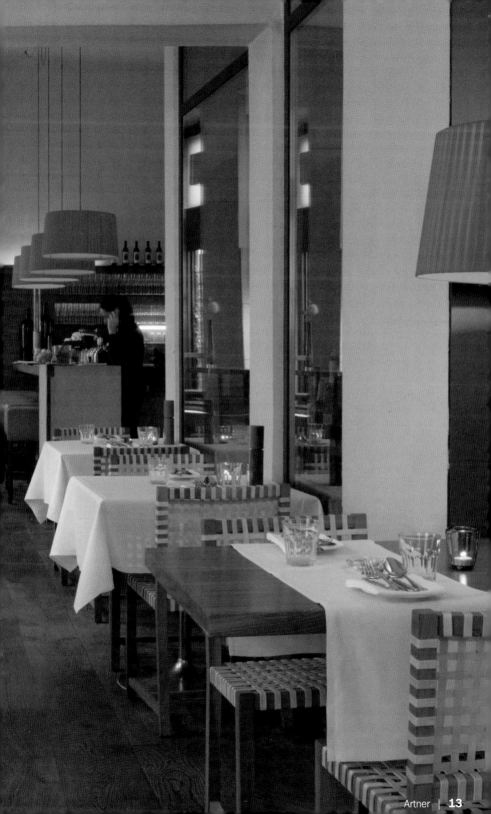

Geschmorte Lammstelze

Braised lamb-stilt

Jarrets d'agneau braisés

Estofado de pie de cordero

Stinco di agnello stufato

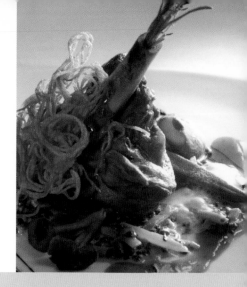

6 Lammstelzen à 250–300 g
2 Karotten, gewürfelt
1 kleiner Sellerie, gewürfelt
2 Zwiebeln, gewürfelt
2 EL Tomatenmark
250 ml Rotwein
2 l Rinderbrühe
1 Lorbeerblatt, 1 EL Pfefferkörner,
1 Zweig Thymian, 1 Knoblauchzehe
Salz, Pfeffer
Olivenöl

Die Lammstelzen mit Salz und Pfeffer würzen, in einer Pfanne mit Olivenöl von allen Seiten scharf anbraten und herausnehmen. Das geputzte und geschnittene Gemüse im Bratenrückstand anbraten bis es gut gebräunt ist. Das Tomatenmark dazugeben und ca. 2–3 Minuten weiterbraten. Mit dem Rotwein ablöschen und der Rinderbrühe aufgießen.
Die Gewürze und die Lammstelzen in den Saft legen und zugedeckt im Ofen ca. 90 Minuten bei 180 °C schmoren.
Wenn die Lammstelzen weich sind, aus dem Fond nehmen und warm stellen. Den Fond mit einem Stabmixer pürieren, noch einmal abschmecken und das Fleisch zurück in die Sauce legen.

6 lamb stilts 10 oz each
2 carrots, diced
1 small celeriac, diced
2 onions, diced
2 tbsp tomato paste
250 ml red wine
2 l beef broth
1 bay leaf, 1 tbsp pepper,
1 twig thyme, 1 glove of garlic
Salt, pepper
Olive oil

Season the lamb stilts with salt and pepper, and fry them sharply in a pan with olive oil from all sides. Take out and fry the cut vegetables in the left oil until golden brown. Add tomato paste and fry for another 2–3 minutes. Fill up with red wine and beef broth.
Put seasonings and lamb stilts back into the fond, cover and braise at 360 °F for 90 minutes.
When lamb stilts are tender, take out and keep warm. Mix the fond with a mixer, season for taste and put the stilts back into the sauce.

6 jarrets d'agneau à 250–300 g
2 carottes en dés
1 petit céleri en dés
2 oignons en dés
2 c. à soupe de concentré de tomates
250 ml de vin rouge
2 l de bouillon de bœuf
1 feuille de laurier, 1 c. à soupe de poivre en grains, 1 brin de thym, 1 gousse d'ail
Sel, poivre
Huile d'olive

Saler et poivrer les jarrets d'agneau et les faire dorer à feu vif de tous les côtés dans l'huile d'olive. Les retirer. Laver et couper les légumes et les faire revenir dans le jus restant jusqu'à ce qu'ils soient bien dorés. Ajouter le concentré de tomates et laisser cuire 2 à 3 minutes supplémentaires. Mouiller avec le vin rouge et verser le bouillon de bœuf.
Mettre les jarrets d'agneau et les épices dans le jus, couvrir, enfourner à 180 °C pendant 90 minutes.
Une fois que la viande est tendre, retirer les jarrets et les réserver au chaud. Passer au mixeur le fond de cuisson, rectifier l'assaisonnement et remettre la viande dans la sauce.

6 pies de cordero de 250–300 g cada uno
2 zanahorias, cortadas a cuadritos
1 apio pequeño, cortado a cuadritos
2 cebollas, cortadas a cuadritos
2 cucharadas de tomate concentrado
250 ml de vino tinto
2 l caldo de carne
1 hoja de laurel, 1 cucharada de granos de pimienta, 1 rama de tomillo, 1 diente de ajo
Sal, pimienta
Aceite de oliva

Sazonar los pies de cordero con sal y pimienta, freírlos intensamente por todos los lados en una sartén con aceite de oliva y sacarlos. Freír la verdura limpia y cortada en los restos del frito hasta que esté bien dorada. Añadir el tomate concentrado y seguir friendo de 2 a 3 minutos aprox. Rebajar con el vino tinto y regar con el caldo de ternera.
Colocar las especias y los pies de cordero en la salsa y asar al horno tapado a 180 °C durante 90 minutos aprox.
Cuando los pies de cordero estén blandos, sacarlos del caldo y ponerlos en lugar caliente. Hacer un puré del caldo con la batidora, sazonar otra vez y colocar la carne nuevamente en la salsa.

6 stinchi di agnello da 250–300 g
2 carote tagliate a dadini
1 sedano piccolo tagliato a dadini
2 cipolle tagliate a dadini
2 cucchiai di concentrato di pomodoro
250 ml di vino rosso
2 l di brodo di manzo
1 foglia di alloro, 1 cucchiaio di grani di pepe, 1 rametto di timo, 1 spicchio d'aglio
Sale, pepe
Olio d'oliva

Salate e pepate gli stinchi di agnello, fateli rosolare bene da tutti i lati in una padella con olio d'oliva, toglieteli quindi dalla padella. Fate rosolare nel fondo di cottura la verdura pulita e tagliata finché sarà ben dorata. Aggiungete il concentrato di pomodoro e fate cuocere ancora per ca. 2–3 minuti. Versate il vino rosso e aggiungete il brodo di manzo.
Mettete le spezie e gli stinchi di agnello nel liquido di cottura e fateli stufare in forno a pentola coperta per ca. 90 minuti a 180 °C.
Non appena gli stinchi di agnello saranno teneri, toglieteli dal fondo di cottura e metteteli in caldo. Con un frullatore ad immersione frullate il fondo di cottura, correggete di nuovo il condimento e rimettete la carne nel sugo.

Babu

Design: Bau Art, Alexander Tavakoli | Chef: Werner Nossal

Stadtbahnbögen 181–184 | 1090 Wien | 9. Bezirk
Phone: +43 1 479 48 49
www.babu.at | office@babu.at
Subway: Nußdorfer Straße
Opening hours: Mon–Sun 8 am to 4 am
Average price: € 14–20
Cuisine: Fusion, Asian
Special features: Terrace, bar scene, member's lounge

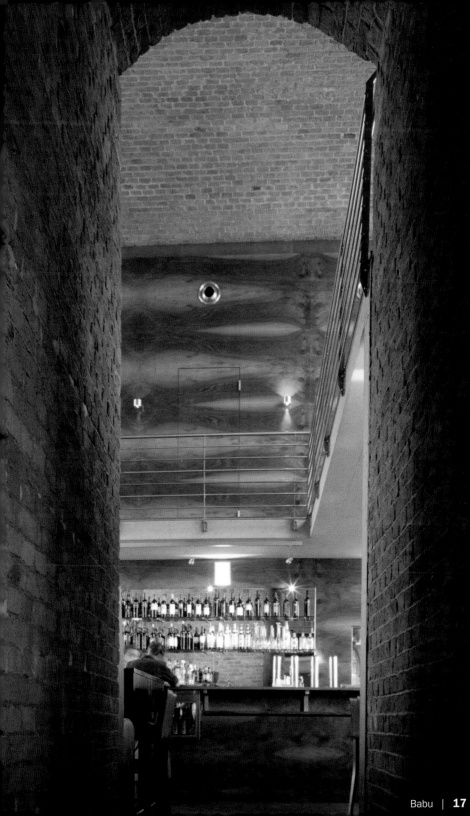

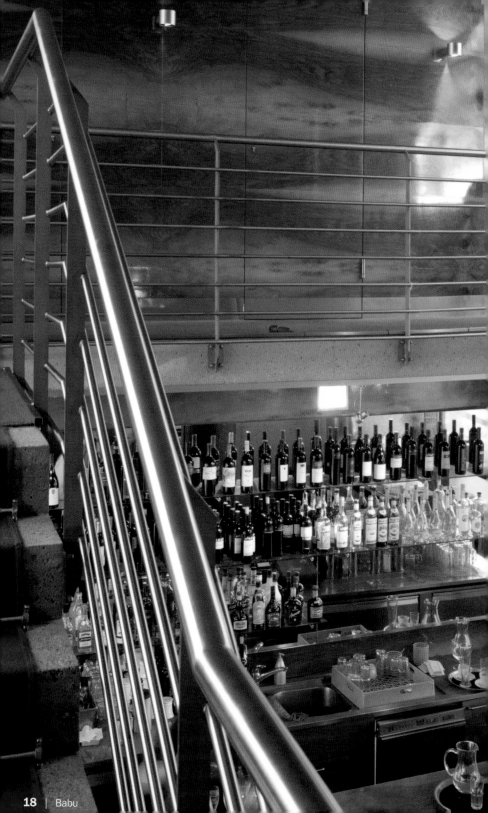

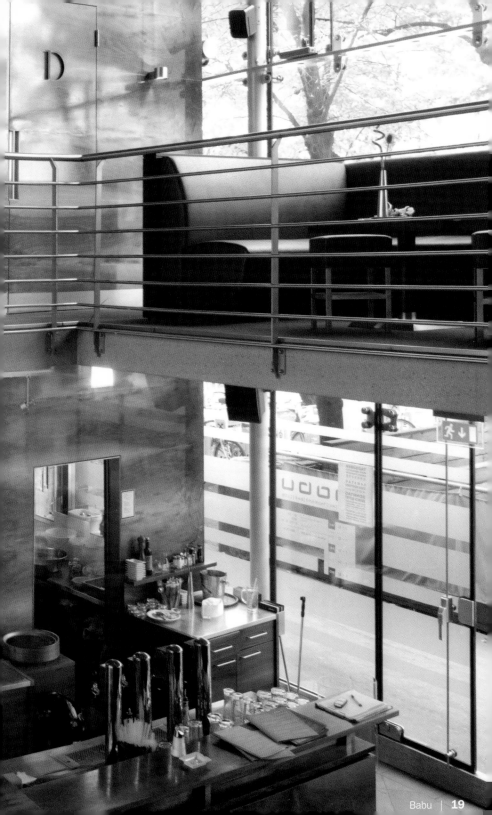

Bar Italia Lounge

Design: Arkan Zeytinoglu | Chef: Nicolas Guerlach

Mariahilfer Straße 19–21 | 1060 Wien | 6. Bezirk
Phone: +43 1 585 28 38
www.baritalia.net | office@baritalia.net
Subway: Neubaugasse, Museumsquartier
Opening hours: Mon–Sat 6:30 pm to 3 am
Average price: € 12
Cuisine: Italian
Special features: Bar scene, celeb hangout, Gault Millau prized

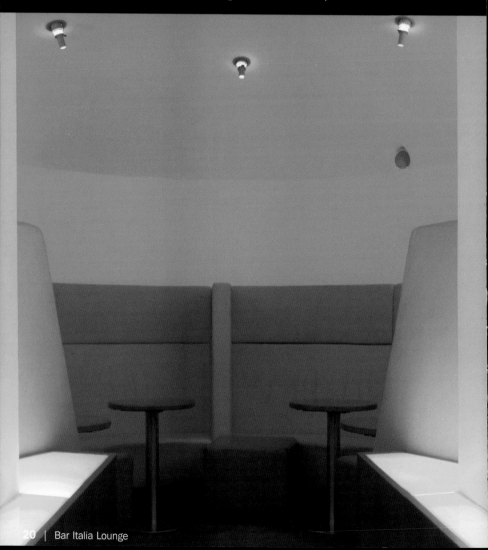

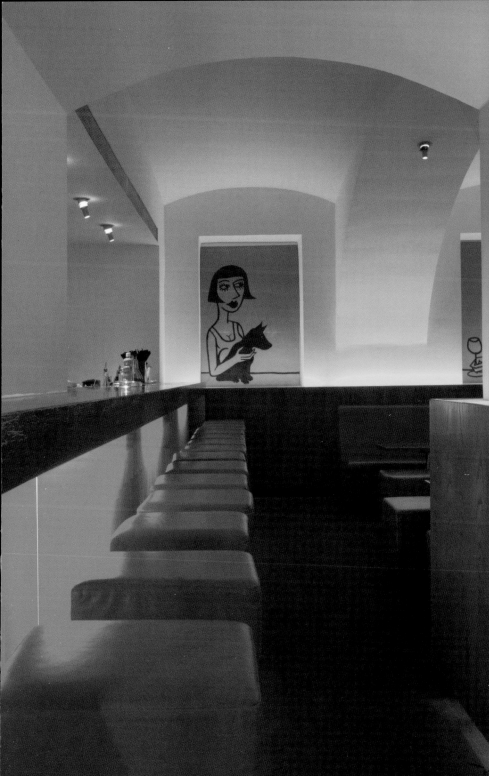

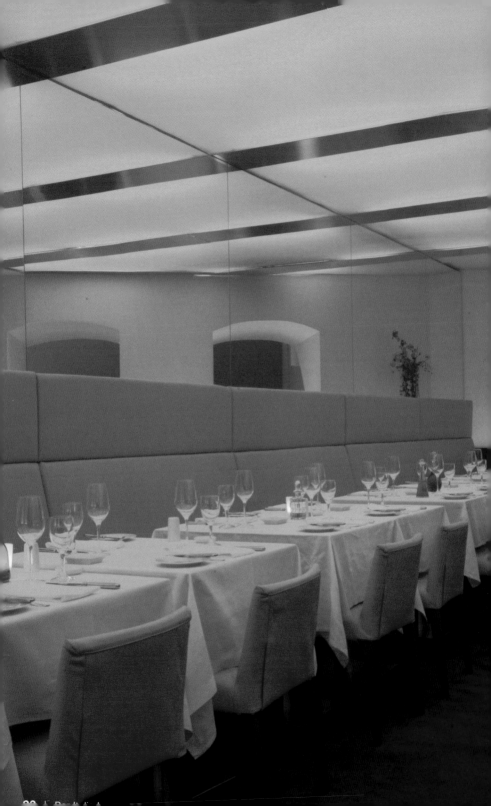

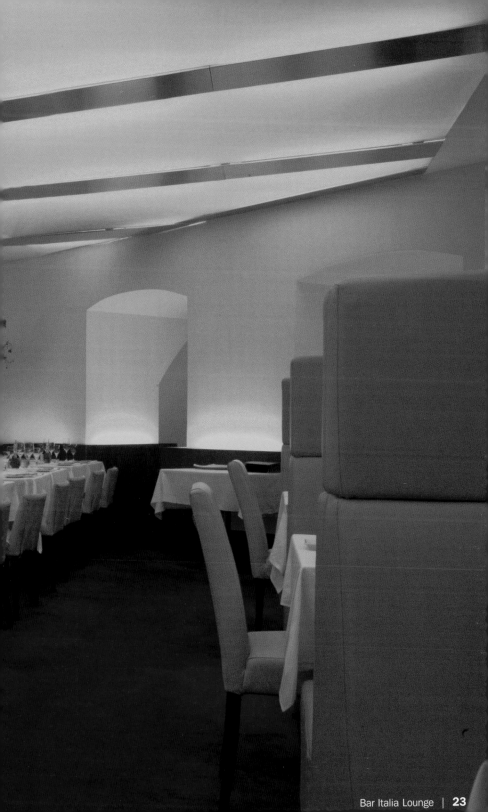

Brunners

Design: Atelier Heiss | Chef: Harald Brunner

Wienerbergstraße 7 | 1100 Wien | 10. Bezirk
Phone: +43 1 607 65 00
www.brunners.at | office@brunners.at
Subway: Philadelphiabrücke
Opening hours: Mon–Fri Lunch 11:30 am to 3 pm, Dinner 6 pm to 12 midnight,
Sat 6 pm to 12 midnight, closed on Sunday
Average price: € 30
Cuisine: Contemporary
Special features: Reservation recommended, wonderful view, Gault Millau prized

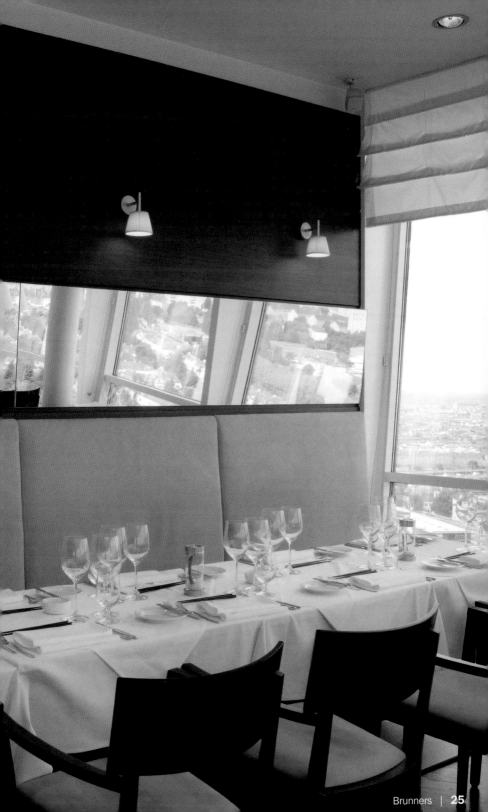

Eismeersaibling
mit Tofu und Curry

Polar Sea Charr with Tofu and Curry

Omble chevalier et tofu au curry

Salvelino del Océano Glacial con tofu y curry

Salmerino artico con tofu e curry

4 Eismeersaiblingfilets à 100 g
3 EL Apfel-Balsamicoessig
4 Saiblingslebern
200 g Tofu, gewürfelt
12 kleine Kartoffeln, gekocht und in Scheiben
3 EL Olivenöl
300 g Pfifferlinge
1 Knoblauchzehe, gehackt
1 rote Zwiebel, gewürfelt
200 g Sojasprossen
2 Chilischoten, gehackt
4 EL Sojasauce, Salz, Pfeffer
2 EL Petersilie, gehackt

Roter Curryschaum:
2 EL rote Currypaste
250 ml Gemüsefond
2 EL Ingwer, gehackt
1 Spritzer Zitronensaft, Salz, Pfeffer

Die Eismeersaiblingfilets in Apfel-Balsamicoessig marinieren.
Für den Curryschaum den Gemüsefond aufkochen, Currypaste, Ingwer und Zitronensaft dazugeben und leicht weiterköcheln lassen. Mit Salz und Pfeffer abschmecken und durch ein Sieb gießen. Separat warm halten.
Den Tofu und die Kartoffeln in einer heißen Pfanne mit etwas Olivenöl rundum goldbraun anbraten. Die Pfifferlinge, Knoblauch, rote Zwiebel, Sprossen und Chili zufügen und kurz sautieren. Mit Sojasauce, Salz, Pfeffer und Petersilie abschmecken.
Die Filets aus der Marinade nehmen, würzen und nur auf der Hautseite ca. 3 Minuten mit der Leber braten.

4 polar sea charr filets, 3 ¹/2 oz each
3 tbsp balsamic vinegar
4 charr livers
7 oz tofu, diced
12 small potatoes, cooked and sliced
3 tbsp olive oil
10 oz chanterelles
1 glove garlic, chopped
1 red onion, diced
7 oz soy bean sprouts
2 chillis, chopped
4 tbsp soy sauce, salt, pepper
2 tbsp parsley, chopped

Red curry sauce:
2 tbsp red curry paste
250 ml vegetable stock
2 tbsp ginger, chopped
1 dash lemon juice, salt, pepper

Marinate the polar sea charr in balsamic vinegar. For the curry sauce bring vegetable stock to a boil, add curry paste, ginger and lemon juice and let simmer. Season with salt and pepper and pour through a strainer. Keep warm separately.
Fry tofu and potatoes in a hot pan in olive oil until golden brown, add chanterelles, garlic, red onion, sprouts, and chillis and sauté. Season with soy sauce, salt, pepper and parsley.
Remove filets from the marinade, season and fry only on the skin side with the liver for ca. 3 minutes.

4 filets d'omble chevalier à 100 g
3 c. à soupe de vinaigre balsamique de pomme
4 foies d'omble
200 g de tofu en dés
12 petites pommes de terre cuites, en rondelles
3 c. à soupe d'huile d'olive
300 g de chanterelles
1 gousse d'ail haché
1 oignon rouge en dés
200 g de pousses de soja
2 piments chili hachés
4 c. à soupe de sauce de soja, sel, poivre
2 c. à soupe de persil haché

Mousse au curry rouge :
2 c. à soupe de pâte au curry rouge
250 ml de fond de légumes
2 c. à soupe de gingembre haché
1 goutte de jus de citron, sel, poivre

Faire mariner les filets d'omble dans le vinaigre balsamique de pomme.
Pour la mousse au curry, faire bouillir le fond de légumes, ajouter la pâte au curry, le gingembre et le jus de citron et laisser mijoter doucement. Assaisonner avec le sel et le poivre. Passer le jus au tamis et le réserver au chaud.
Faire dorer le tofu et les pommes de terre de tous les côtés dans un peu d'huile d'olive. Ajouter les chanterelles, l'ail, l'oignon rouge, les pousses de soja et le chili et faire revenir brièvement. Assaisonner avec la sauce de soja, le sel, le poivre et le persil.
Retirer les filets de la marinade et les épicer. Les frire seulement côté peau avec les foies pendant 3 minutes.

4 filetes de salvelino del Océano Glacial de 100 g
3 cucharadas de vinagre balsámico de manzana
4 hígados de salvelino
200 g de tofu, cortado a cuadritos
12 patatas pequeñas, cocidas y a rodajas
3 cucharadas de aceite de oliva
300 g de cantarelas
1 diente de ajo, picado
1 cebolla roja, cortada a cuadritos
200 g de brotes de soja
2 chiles, picados
4 cucharadas de salsa de soja, sal, pimienta
2 cucharadas de perejil, picado

Espuma roja de curry:
2 cucharadas de pasta roja de curry
250 ml de caldo de verduras
2 cucharadas de jengibre, picado
1 chorrito de jugo de limón, sal, pimienta

Marinar los filetes de salvelino del Océano Glacial en vinagre balsámico de manzana.
Hervir el caldo de verduras para la espuma de curry, añadir la pasta de curry, el jengibre y el jugo del limón y dejar hervir ligeramente a fuego lento. Sazonar con sal y pimienta y verter por un colador.
Freír el tofu y las patatas por todos los lados en una sartén caliente con algo de aceite de oliva hasta dorarlos. Añadir las cantarelas, el ajo, las cebollas rojas, los brotes de soja y el chile y saltearlos brevemente. Sazonar con la salsa de soja, la sal, la pimienta y el perejil.
Sacar los filetes de la marinada, condimentar y freír con el hígado sólo por la parte de la piel durante 3 minutos aprox.

4 filetti di salmerino artico da 100 g
3 cucchiai di aceto balsamico di mela
4 fegati di salmerino
200 g di tofu tagliato a dadini
12 patate piccole lessate e tagliate a fette
3 cucchiai di olio d'oliva
300 g di funghi gallinacci
1 spicchio d'aglio tritato
1 cipolla rossa tagliata a dadini
200 g di germogli di soia
2 peperoncini tritati
4 cucchiai di salsa di soia, sale, pepe
2 cucchiai di prezzemolo tritato

Spuma di curry rosso:
2 cucchiai di pasta di curry rossa
250 ml di brodo vegetale
2 cucchiai di zenzero tritato
1 spruzzo di succo di limone, sale, pepe

Fate marinare i filetti di salmerino artico nell'aceto balsamico di mela.
Per la spuma di curry portate ad ebollizione il brodo vegetale, aggiungete la pasta di curry, lo zenzero e il succo di limone e fate continuare a cuocere a fuoco lento. Correggete con sale e pepe e versatelo in un passaverdura. Tenetelo da parte in caldo.
In una padella molto calda fate rosolare uniformemente il tofu e le patate con un po' di olio d'oliva finché diventeranno di un colore ben dorato. Aggiungete i funghi gallinacci, l'aglio, la cipolla rossa, i germogli e i peperoncini e fateli saltare per qualche istante. Insaporite con salsa di soia e prezzemolo e correggete con sale e pepe.
Togliete i filetti dalla marinata, conditeli e friggeteli solo superficialmente con il fegato per ca. 3 minuti.

Buddha Club

Design: Megan Dotzova | Chef: Meinrad Neunkirchner

Währingergürtel Stadtbahnbogen 172–175 | 1090 Wien | 9. Bezirk
Phone: +43 1 479 88 49
www.buddha-club.at | reservierung@buddha-club.at
Subway: Währinger Straße
Opening hours: Every day 6:30 am to 3 am
Average price: € 30
Cuisine: Modern Asian, Fusion
Special features: Reservation recommended, brunch, bar scene

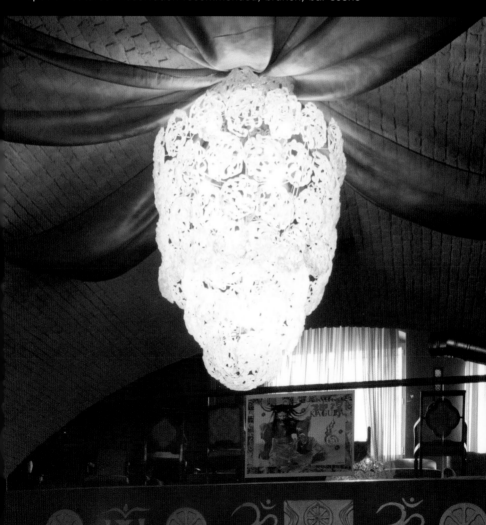

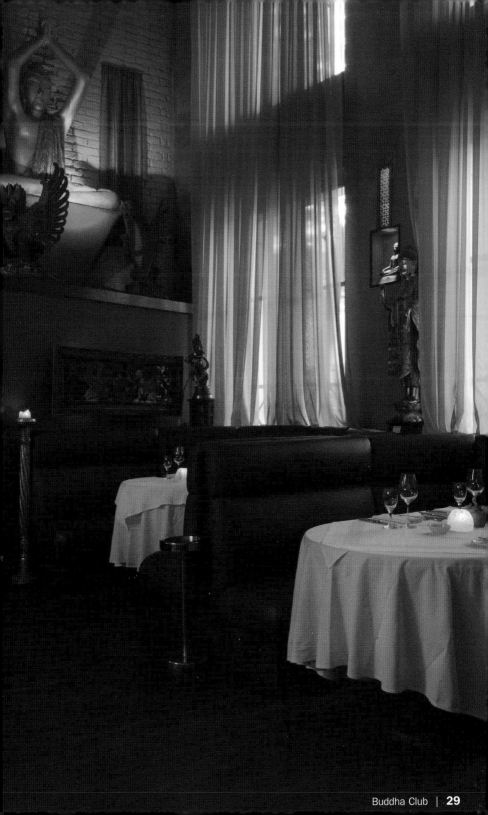

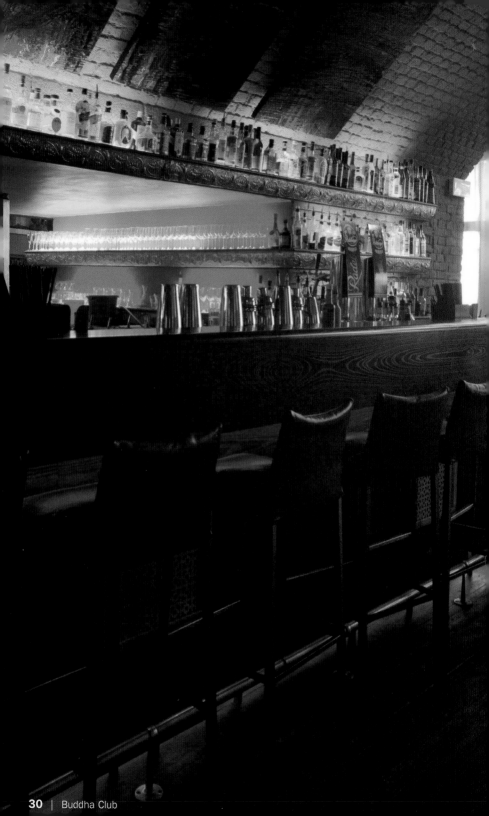

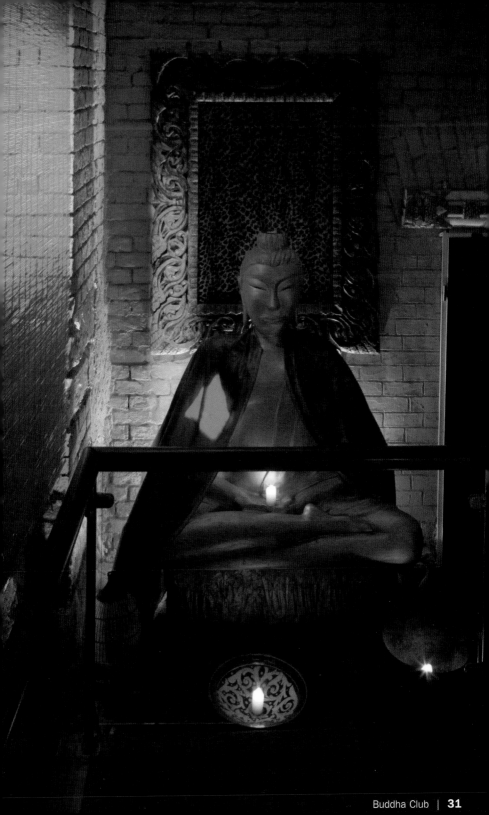

Marinierter Thunfisch

mit Chinakohl und Curry

Marinated Thuna
with Chinese Leaves and Curry

Thon mariné et chou de Chine au curry

Atún marinado con col rizada y curry

Tonno marinato con cavolo cinese e curry

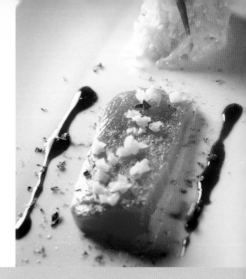

100 g Chinakohl
Salz, Pfeffer
1 EL Sojaöl
2 EL Reisweinessig
4 mitteldicke Scheiben frischer Thunfisch à 70 g
Gemahlenes Meersalz
Weißer Pfeffer aus der Mühle
Korianderblätter, gehackt
1 TL gehackter Sushi-Ingwer
1 Prise mildes Curry
2 EL süße Sojasauce
4 Estragonzweige

Chinakohl in feine Streifen schneiden und mit Salz, Pfeffer, Öl und Essig marinieren.
Thunfischscheiben auf den Tellern verteilen, mit Salz, Pfeffer und Koriander würzen und mit Ingwer und Curry bestreuen. Ca. 3 Minuten marinieren.
Neben den Thunfisch etwas marinierten Chinakohl setzen und mit Estragonzweigen und Sojasauce garnieren.

3 ¹/₂ oz Chinese leaves
Salt, pepper
1 tbsp soy oil
2 tbsp rice vinegar
4 medium thick slices of fresh thuna, 2 oz each
Grounded sea salt
White pepper from the mill
Cilantro leaves, chopped
1 tsp sushi ginger, chopped
1 pinch sweet curry
2 tbsp sweet soy sauce
4 twigs of tarragon

Cut chinese leaves in thin stripes and marinate with salt, pepper, oil and vinegar.
Place thuna on plates and sprinkle with salt, pepper, cilantro, ginger and curry. Let set for 3 minutes.
Place marinated chinese leaves next to thuna and decorate with tarragon twigs and soy sauce.

100 g de chou de Chine
Sel, poivre
1 c. à soupe d'huile de soja
2 c. à soupe de vinaigre de riz
4 tranches de thon frais à 70 g
Sel marin moulu
Poivre blanc du moulin
Feuilles de coriandre hachées
1 c. à café de gingembre mariné haché
1 pincée de curry doux
2 c. à soupe de sauce de soja sucrée
4 brins d'estragon

Tailler le chou de Chine en fines lanières et faire mariner dans l'huile et le vinaigre, saler et poivrer.
Disposer les tranches de thon sur les assiettes, assaisonner avec le sel, le poivre et la coriandre et saupoudrer de gingembre et de curry. Faire mariner pendant 3 minutes.
Disposer un peu de chou de Chine mariné à côté du thon, garnir avec les brins d'estragon et la sauce de soja.

100 g de col rizada
Sal, pimienta
1 cucharada de aceite de soja
2 cucharadas de vinagre de vino de arroz
4 rodajas medio gruesas de atún de 70 g cada una
Sal marina molida
Pimienta blanca del molinillo
Hojas de cilantro, picado
1 cucharadita de jengibre de sushi
1 pizca de curry suave
2 cucharadas de salsa de soja dulce
4 ramas de estragón

Cortar la col rizada a tiras finas y marinar con la sal, la pimienta, el aceite y el vinagre.
Distribuir las rodajas de atún en los platos y condimentar con sal, pimienta y cilantro y espolvorear con el jengibre y el curry. Marinar durante 3 minutos aprox.
Poner algo de la col rizada marinada al lado del atún y adornar con ramas de estragón y salsa de soja.

100 g di cavolo cinese
Sale, pepe
1 cucchiaio di olio di soia
2 cucchiai di aceto di vino di riso
4 fette medie di tonno fresco da 70 g
Sale marino macinato
Pepe bianco appena macinato
Foglie di coriandolo tritate
1 cucchiaino di zenzero in salamoia tritato
1 pizzico di curry dolce
2 cucchiai di salsa di soia dolce
4 rametti di dragoncello

Tagliate il cavolo cinese a striscioline e fatelo marinare con sale, pepe, olio e aceto.
Distribuite le fette di tonno sui piatti, conditele con sale, pepe e coriandolo e cospargetele di zenzero e curry. Fate marinare per ca. 3 minuti.
Disponete un po' di cavolo cinese marinato vicino al tonno e guarnite con rametti di dragoncello e salsa di soia.

Café Berg

Design: Georg Ender | Chef: Georg Ender & Team

Berggasse 8 | 1090 Wien | 9. Bezirk
Phone: +43 1 319 57 20
www.cafe-berg.at | mail@cafe-berg.at
Subway: Schottentor
Opening hours: Every day 10 am to 1 am
Average price: € 13
Cuisine: Contemporary
Special features: Brunch, terrace, gay community

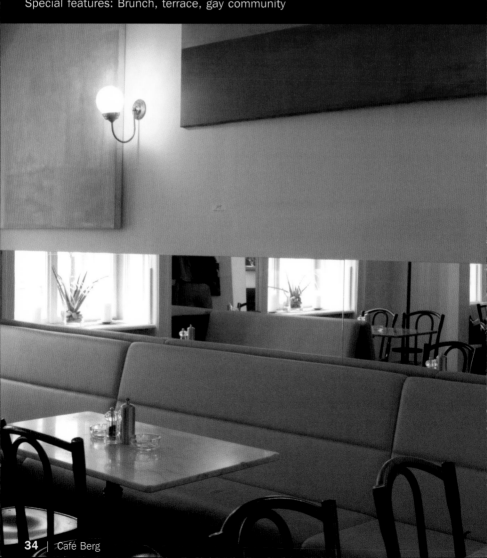

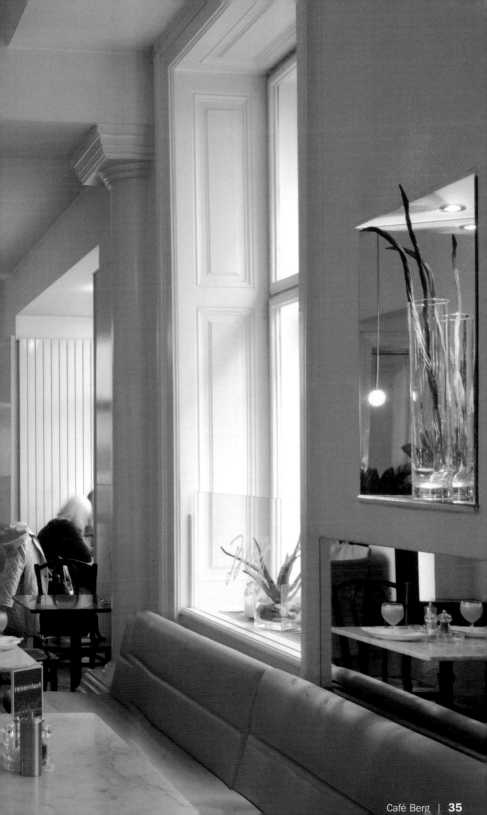

Café-Restaurant Una

Design: Lacaton & Vassal | Chef: Una Abraham

Museumsplatz 1 | 1070 Wien | 7. Bezirk
Phone: +43 1 523 65 66
www.azw.at | office@azw.at
Subway: Volkstheater
Opening hours: Mon–Fri 9 am to 12 midnight, Sat 10 am to 12 midnight,
Sun 10 am to 6 pm
Average price: € 18
Cuisine: International
Special features: Architects and designer scene

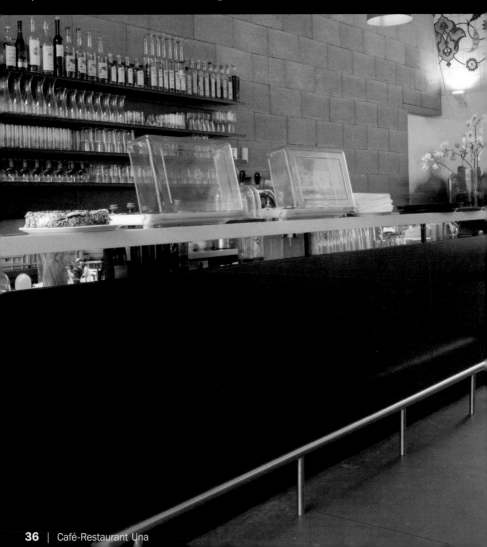

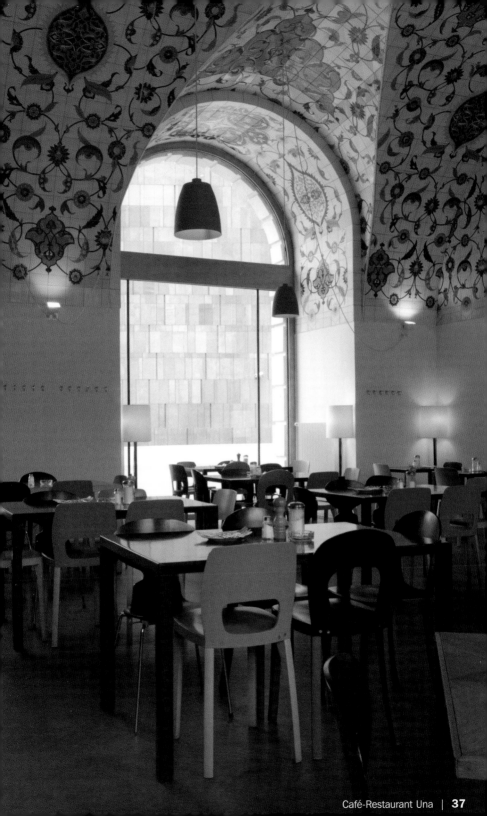

Marchfelder
Baby-Artischocken
in Zitronenbutter

Marchfeld Baby Artichokes in Lemon Butter

Mini-artichauts de Marchfeld au beurre citronné

Alcachofas pequeñas de Marchfeld en mantequilla de limón

Carciofi piccoli di Marchfeld in burro al limone

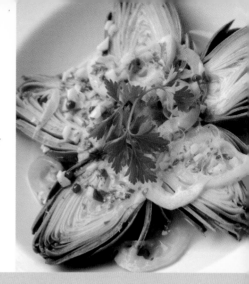

12 Baby-Artischocken
5 unbehandelte Zitronen
400 g Butter
Salz, Pfeffer
50 ml Weißwein
Rosa Pfefferbeeren
Blattpetersilie

Die Artischocken in ausreichend Salzwasser mit 4 halbierten Zitronen ca. 30 Minuten kochen, bis sich die Blätter leicht lösen lassen. Die übrige Zitrone halbieren und in dünne Scheiben schneiden. Butter mit Zitronenscheiben und Weißwein leicht köcheln lassen und mit Salz, Pfeffer und rosa Pfefferbeeren abschmecken.
Die gekochten Artischocken längs halbieren und mit der Schnittfläche nach unten 2–3 Minuten in der Sauce ziehen lassen.
Mit der Schnittfläche nach oben 6 Artischockenhälften auf jedem Teller anrichten, mit Zitronenscheiben und Petersilie garnieren und mit etwas Zitronenbutter beträufeln.

12 baby artichokes
5 untreated lemons
14 oz butter
Salt, pepper
50 ml white wine
Pink pepperberries
Parsley leaves

Cook artichokes in salted water with four lemons for 30 minutes, until the leaves are tender. Cut the last lemon in thin slices. Bring butter with lemon slices and white wine to a boil and let simmer lightly. Season with salt, pepper and pepperberries.
Cut the cooked artichokes in half and marinate with the cut side down in the sauce for 2–3 minutes.
Place six artichockes with the cut side up on each plate, garnish with lemon slices and parsley and sprinkle with lemon butter.

12 mini-artichauts
5 citrons non traités
400 g de beurre
50 ml de vin blanc
Baies de poivre rose
Sel, poivre
Persil

Faire cuire environ 30 minutes les
quatre moitiés de citron dans suffisam.
salée jusqu'à ce que les feuilles se c
facilement. Couper les autres citrons ei.
et les tailler en fines rondelles. Laisser mij
doucement le citron et le vin blanc et assaisonne
avec le sel, le poivre et les baies de poivre rose.
Couper les artichauts cuits dans la longueur, les
poser sur la surface coupée et les laisser macérer
dans la sauce 2 à 3 minutes.
Dresser sur chaque assiette 6 moitiés d'artichaut,
la surface coupée vers le haut, garnir avec les
rondelles de citron, le persil et un peu de beurre
citronné.

12 alcachofas pequeñas
5 limones no tratados
400 g de mantequilla
Sal, pimienta
50 ml de vino blanco
Bayas de pimienta rosa
Perejil

Hervir las alcachofas en suficiente agua con sal
con 4 limones cortados por la mitad durante 30
minutos hasta que las hojas se puedan despren-
der fácilmente. Cortar el limón restante por la
mitad y después a rodajas finas. Hacer hervir lige-
ramente la mantequilla con las rodajas de limón
y el vino blanco a fuego lento y sazonar con sal,
pimienta y las bayas de pimienta rosa.
Cortar las alcachofas hervidas por la mitad a lo
largo y dejar reposar en la salsa con la superficie
de corte hacia abajo durante 2–3 minutos.
Colocar en cada plato 6 mitades de alcachofas
con la parte de corte hacia arriba, adornar con
rodajas de limón y perejil y rociar con algo de
mantequilla al limón.

12 carciofi piccoli
5 limoni non trattati
400 g di burro
Sale, pepe
50 ml di vino bianco
Bacche di pepe rosa
Prezzemolo

Lessate i carciofi in abbondante acqua salata con
4 limoni tagliati a metà per ca. 30 minuti finché
le foglie si staccheranno facilmente. Dividete a
metà il limone rimasto e tagliatelo a fettine sottili.
Fate cuocere a fuoco lento il burro con le fette
di limone e il vino bianco e correggete con sale,
pepe e bacche di pepe rosa.
Tagliate i carciofi lessati a metà nel senso della
lunghezza e lasciateli macerare per 2–3 minuti
nella salsa con la superficie tagliata rivolta verso
il basso.
Mettete su ogni piatto 6 metà di carciofi con la
superficie tagliata rivolta verso l'alto, guarnite con
fette di limone e prezzemolo e versatevi un po' di
burro al limone.

...inetta Antinori

...hmidt | Chef: Gottfried Krasser

Jasomirgottstraße 3–5 | 1010 Wien | 1. Bezirk
Phone: +43 1 533 77 22
www.antinori.it | antinori@antinori.it
Subway: Stephansplatz
Opening hours: Every day 11:30 am to 12 midnight
Average price: € 22
Cuisine: Tuscan
Special features: Reservation recommended, own winery, Michelin prized

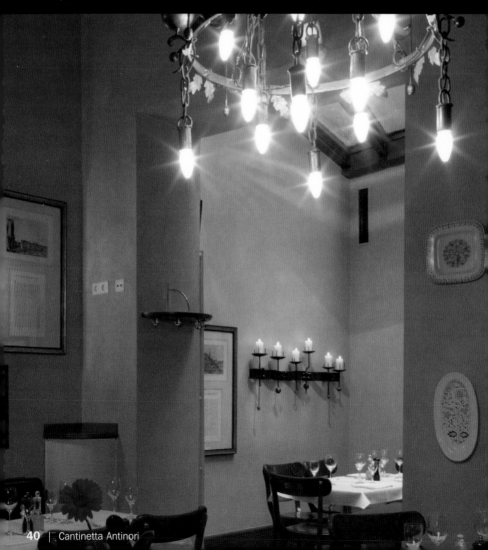

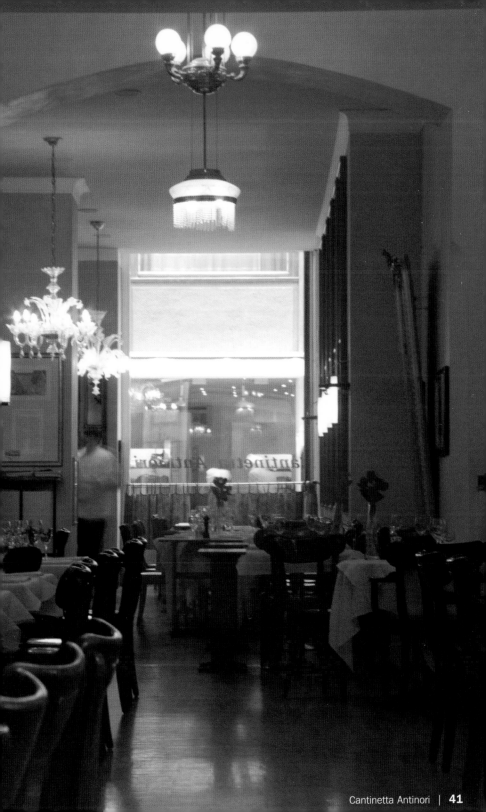

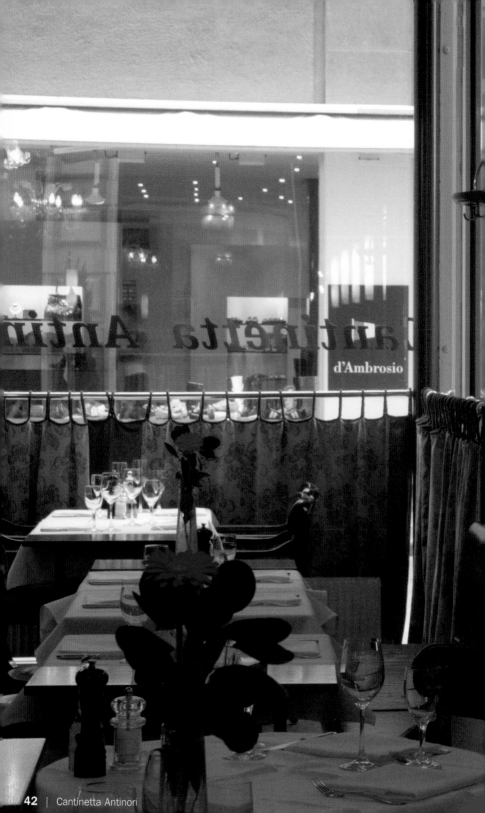

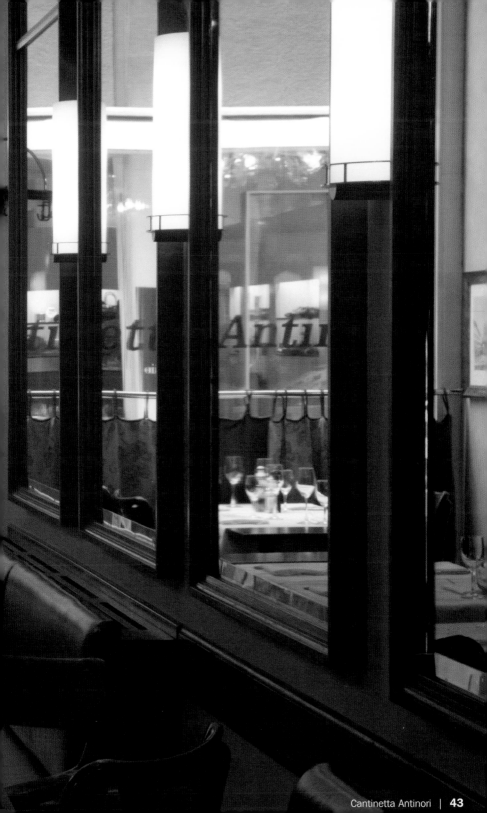

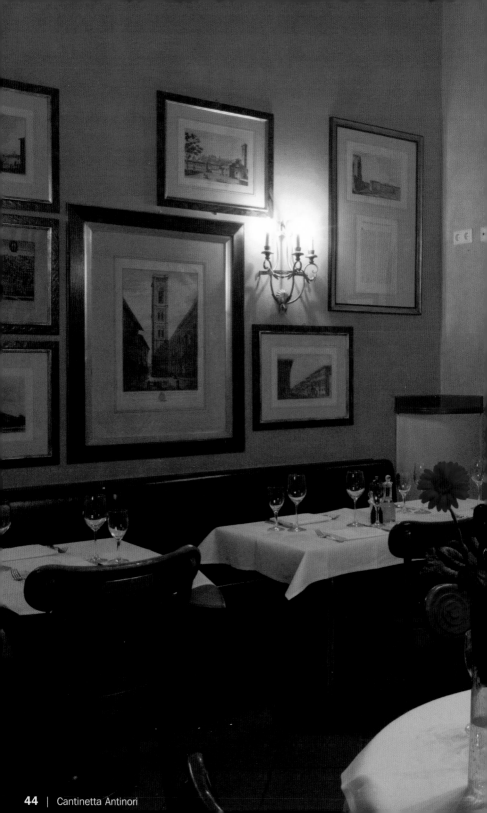

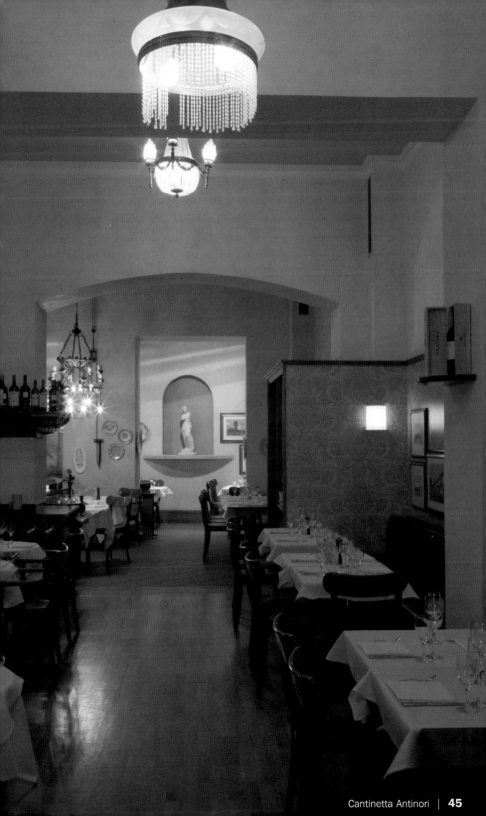

Collio

Design: Terence Conran | Chef: Josef Neuherz

Wiednerhauptstraße 12 | 1040 Wien | 4. Bezirk
Phone: +43 1 589 18 133
www.dastriest.at | office@dastriest.at
Subway: Karlsplatz
Opening hours: Mon–Fri 12 noon to 2:30 pm, Mon–Sat 6:30 pm to 10 pm,
closed on Sunday
Average price: € 40
Cuisine: Modern Italian
Special features: Reservation recommended, private rooms, Gault Millau prized

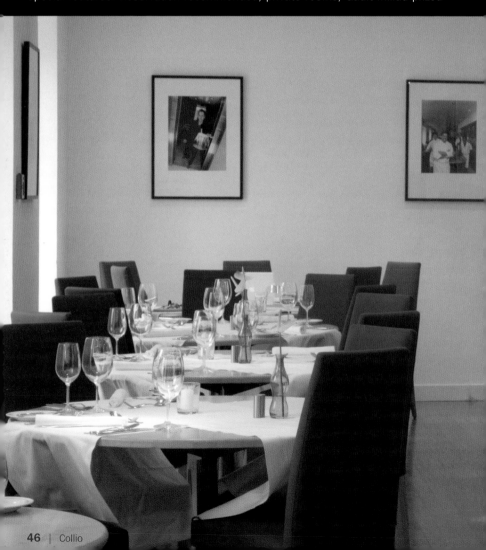

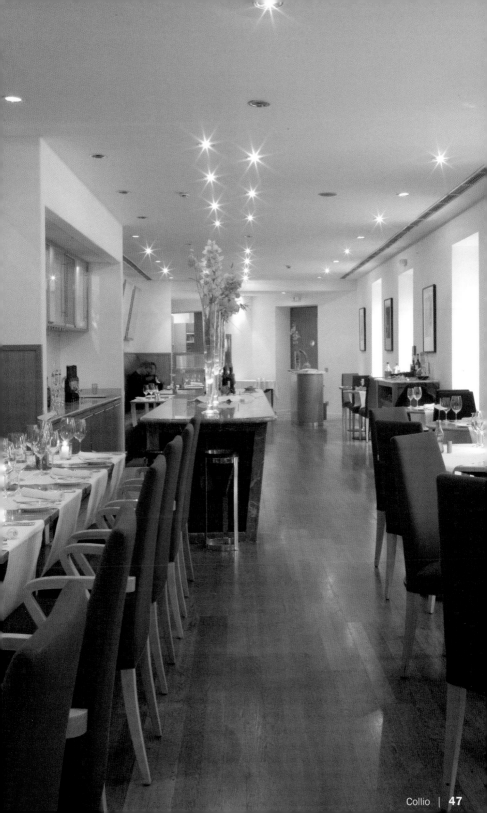

Seeteufel-medaillons

mit Jakobsmuscheln auf Kürbis-püree und gegrilltem Gemüse

Anglerfish Medaillons with Great Scallops on Pumpkin Purée and Grilled Vegetables

Médaillons de lotte et coquilles Saint-Jacques sur lit de potiron et de légumes

Medallones de rape con vieiras en puré de calabaza y verdura asada

Medaglioni di coda di rospo con capesante su purea di zucca e verdura grigliata

240 g Seeteufelfilet
100 g Jacobsmuschelfleisch
Saft und Schale einer Limette
3 EL Salbeiblätter, geschnitten
Pfeffer

200 g Kürbisfleisch
1 Zwiebel, gewürfelt
1 Knoblauchzehe, gewürfelt
1/2 Chillischote, gewürfelt
4 EL Olivenöl
Salz, Pfeffer
1 Zucchini, in Scheiben
1 Fenchel, in kleinen Spalten
1 rote und gelbe Paprika, in Streifen
Salz, Pfeffer, Thymian, Knoblauchzehe
Einige Rucolablätter und gegarte Miesmuscheln als Dekoration

Seeteufelfilet in Medaillons schneiden und mit Pfeffer, Limettensaft und Salbei marinieren. Die Jacobsmuscheln in Scheiben schneiden und mit geriebener Limettenschale und Pfeffer marinieren.
Das Kürbisfleisch in kleine Würfel schneiden und zusammen mit der gehackten Zwiebel, Knoblauch und Chillischote in etwas Olivenöl ohne Farbe ca. 20 Minuten anschwitzen. Mit Salz und Pfeffer abschmecken und fein pürieren. Zucchini, Fenchel, rote und gelbe Paprika in einer Grillpfanne mit Olivenöl grillen und bissfest garen. Mit Salz, Pfeffer, frischen Thymian und etwas Knoblauch würzen. Seeteufelmedaillons und Jacobsmuscheln in einer Pfanne ca. 3 Minuten braten. Kürbispüree auf Tellern anrichten, das gegrillte Gemüse darauf geben, einige Rucolablätter darum verteilen und darauf die gebratenen Seeteufelmedaillons und Jacobsmuscheln platzieren. Evtl. mit Pesto und Tomatensauce garnieren.

9 oz anglerfish filet
3 1/2 oz great scallop meat
Lime peel and juice
3 tbsp sage leaves, cut
Pepper

7 oz pumpkin meat
1 onion, diced
1 glove garlic, chopped
1/2 chilli, chopped
4 tbsp olive oil
Salt, pepper
1 zucchini, sliced
1 fennel, small slices
1 red and yellow bell pepper, sliced
Salt, pepper, thyme, glove garlic
Few leaves of rucola and stewed mussels for decoration

Cut anglerfish filet into medaillons and marinade with pepper, lime juice and sage. Cut great scallops in thin slices and marinade with lime peel and pepper.
Cut pumpkin meat in small cubes and sauté with onions, garlic and chilli in olive oil without colour for 20 minutes. Season with salt and pepper and mix until smooth. Grill zucchini, fennel, red and yellow bell peppers in a grilling pan with olive oil until tender. Season with salt, pepper, fresh thyme and garlic. Fry anglerfish and scallops in a pan for about 3 minutes. Spoon pumpkin purée on plates, put vegetables around, decorate with rucola leaves and place anglerfish and scallops on top. Garnish with pesto and tomato sauce.

240 g de filet de lotte
100 g de chair de coquilles Saint-Jacques
Jus et zeste d'une limette
3 c. à soupe de feuilles de sauge ciselées
Poivre

200 g de chair de potiron
1 oignon en dés
1 gousse d'ail en dés
1/2 piment chili en dés
4 c. à soupe d'huile d'olive
1 courgette en rondelles
1 fenouil en lamelles
1 poivron rouge et jaune en lanières
Sel, poivre, thym, gousses d'ail
Quelques feuilles de roquette et des moules cuites pour la décoration

Découper la lotte en médaillons et faire mariner avec le poivre, le jus de limette et la sauge. Couper la chair des coquilles Saint-Jacques en lamelles et faire mariner avec le zeste de limette et le poivre. Couper la chair de potiron en petits cubes et faire cuire une vingtaine de minutes avec l'oignon haché, l'ail et le chili dans un peu d'huile incolore. Assaisonner avec le sel et le poivre et mixer jusqu'à l'obtention d'une fine purée. Faire cuire al dente la courgette, le fenouil, les poivrons rouge et jaune dans l'huile d'olive. Assaisonner avec le sel, le poivre, le thym frais et un peu d'ail. Faire revenir à la poêle 3 minutes les médaillons de lotte et les coquilles Saint-Jacques. Dresser sur les assiettes la purée de potiron et les légumes grillés, parsemer de roquette et déposer les médaillons de lotte et les coquilles Saint-Jacques sur le dessus. Eventuellement, ajouter du pesto et de la sauce tomate.

240 g de filetes de rape
100 g de carne de vieiras
El zumo y la piel de una lima
3 cucharadas de salvia, cortada
Pimienta

200 g de calabaza sin cáscara
1 cebolla, cortada a cuadritos
1 diente de ajo, cortado a cuadritos
1/2 chile, cortado a cuadritos
4 cucharadas de aceite de oliva
Sal, pimienta
1 calabacín, a rodajas
1 hinojo, a partes pequeñas
1 pimiento rojo y amarillo, a tiras
Sal, pimienta, tomillo, diente de ajo
Algunas hojas de rúcola y mejillones hervidos como decoración

Cortar el filete de rape a medallones y marinar con la pimienta, el zumo de lima y la salvia. Cortar las vieiras a rodajas y marinarlas con pimienta y la piel rallada de la lima. Cortar la calabaza a cuadritos pequeños y dorar durante 20 minutos aprox. en algo de aceite de oliva sin color junto con la cebolla picada, el ajo y el chile. Sazonar con sal y pimienta y hacer un puré fino. Asar en una parrilla con aceite de oliva el calabacín, el hinojo, el pimiento rojo y el amarillo y dejar casi cocidos. Condimentar con sal, pimienta, tomillo fresco y algo de ajo. Freír los medallones de rape y las vieiras en una sartén durante 3 minutos aprox. Colocar el puré de calabaza en platos, poner la verdura asada encima, esparcir por ella algunas hojas de rúcola y poner encima los medallones de rape fritos y las vieiras. Adornar eventualmente con pesto y salsa de tomate.

240 g di filetto di coda di rospo
100 g di polpa di capesante
Succo e scorza di una limetta
3 cucchiai di foglie di salvia tagliate
Pepe

200 g di polpa di zucca
1 cipolla tagliata a dadini
1 spicchio d'aglio tagliato a dadini
1/2 peperoncino tagliato a dadini
4 cucchiai di olio d'oliva
Sale, pepe
1 zucchina a fette
1 finocchio a spicchi piccoli
1 peperone rosso e giallo a striscioline
Sale, pepe, timo, spicchio d'aglio
Alcune foglie di rucola e mitili cotti per decorare

Tagliate il filetto di coda di rospo a medaglioni e fatelo marinare con pepe, succo di limetta e salvia. Tagliate le capesante a fette e fatele marinare con scorza di limetta grattugiata e pepe. Tagliate la polpa di zucca a dadini e fatela dorare insieme alla cipolla tritata, all'aglio e al peperoncino in un po' di olio d'oliva per ca. 20 minuti senza che prenda troppo colore. Correggete con sale e frullatela finemente. In una padella a griglia grigliate con l'olio d'oliva la zucchina, il finocchio, il peperone rosso e giallo e fateli cuocere al dente. Condite con sale, pepe, timo fresco e un po' d'aglio. In una padella friggete per ca. 3 minuti i medaglioni di coda di rospo e le capesante. Mettete la purea di zucca sui piatti, sistematevi sopra la verdura grigliata, distribuite intorno alcune foglie di rucola e disponetevi sopra i medaglioni di coda di rospo e le capesante fritti. Guarnite eventualmente con pesto e salsa di pomodoro.

Do & Co Albertina

Design: Zetinoglu Arkan | Chef: Christina Ostermayer

Albertinaplatz 1 | 1010 Wien | 1. Bezirk
Phone: +43 1 532 96 69
www.doco.com | albertina@doco.com
Subway: Karlsplatz
Opening hours: Every day 10 am to 12 midnight
Average price: € 15
Cuisine: International
Special features: Terrace, offers breakfast

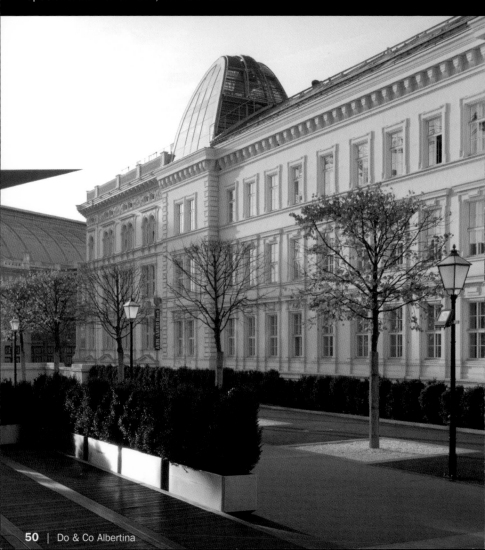

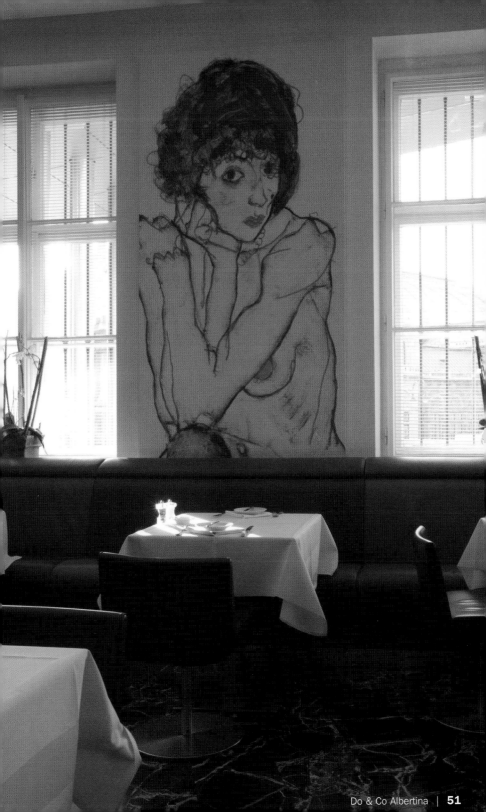

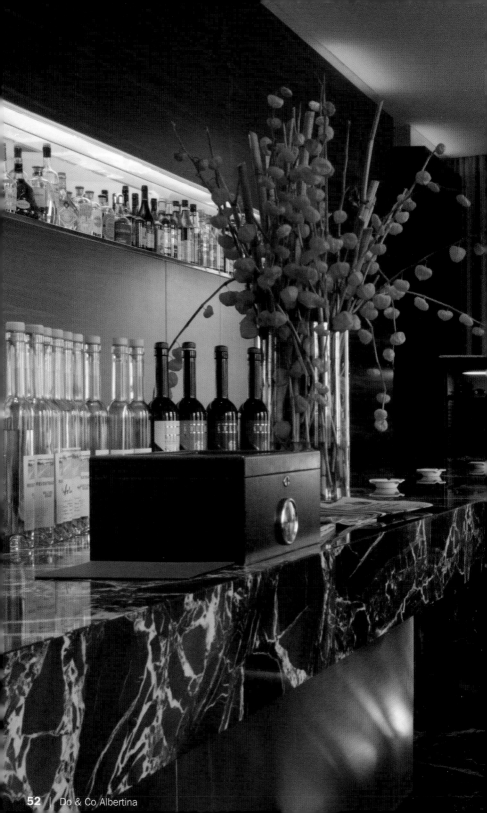

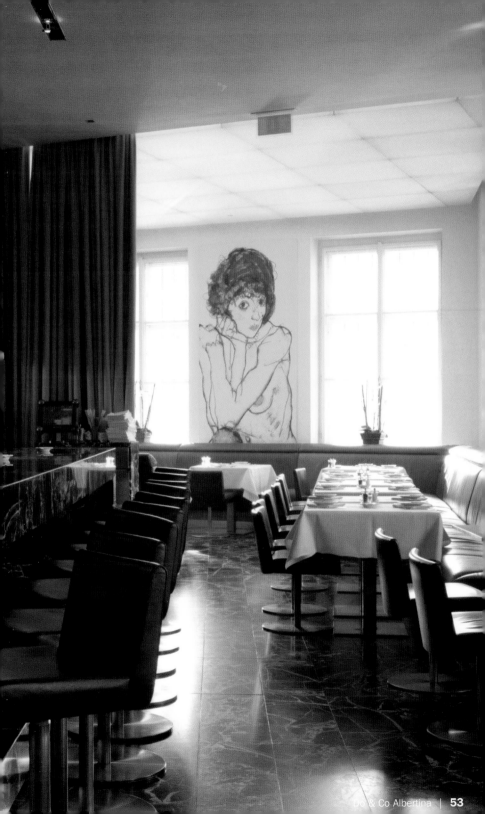

Fabios

Design: BEHF Architekten
Chef: Christoph Brunnhuber, Fabio Giacobello

Tuchlauben 6 | 1010 Wien | 1. Bezirk
Phone: +43 1 532 22 22
www.fabios.at | fabios@fabious.at
Subway: Herrengasse
Opening hours: Mon–Sat 10 am to 1 am, Kitchen open 12 noon to 11:30 pm
Average price: € 45
Cuisine: Innovative Mediterran
Special features: Reservation essential, Michelin and Gault Millau prized

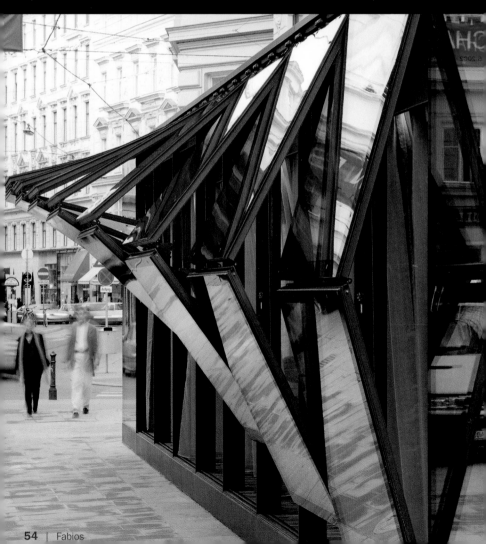

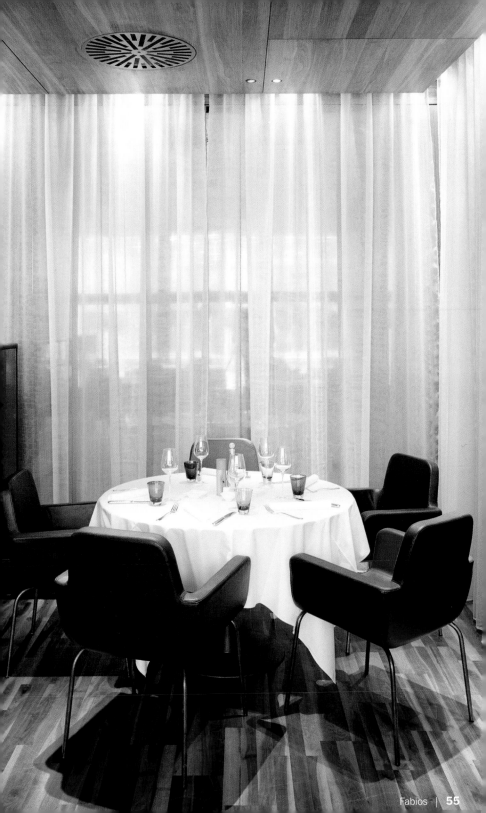

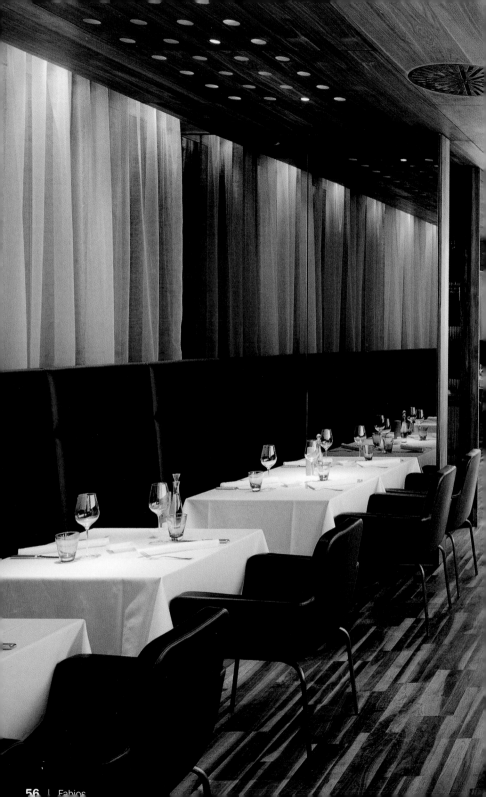

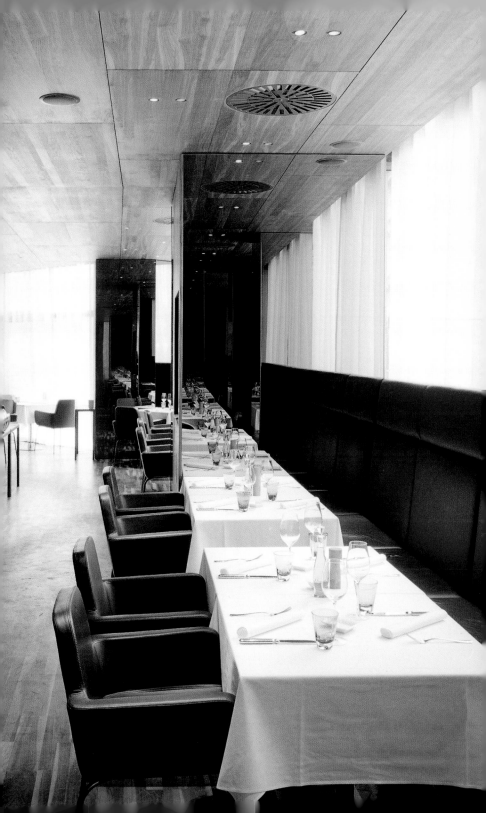

Rote Rüben-Gnocchi

mit wildem Steinbutt

Red Turnip Gnocchi with Wild Turbot

Gnocchi aux betteraves rouges et turbot sauvage

Gnocchi a la remolacha roja con rodaballo silvestre

Gnocchi di barbabietola con rombo selvaggio

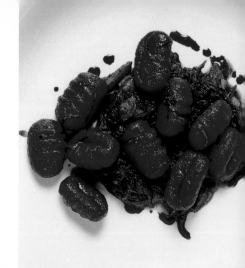

750 g mehlige Kartoffeln
3 Eigelbe
100 g Grieß
200 g Mehl
Salz, Pfeffer, Muskat
2 Granny-Smith-Äpfel
100 g Crème fraîche
Limonenzeste, Salz, Pfeffer
1 Flasche Rote-Rüben-Saft
1 Zweig Thymian
3 EL Olivenöl
4 große Steinbuttfilets
2 EL Butter
2 Zweige Thymian

Kartoffeln kochen, pellen und noch heiß durch eine Kartoffelpresse drücken. Mit Eigelben, Grieß, Mehl und Gewürzen einen Teig herstellen. Zu gleichmäßigen Rollen abdrehen, in ca. 2 cm lange Stücke schneiden und zu Gnocchi formen. Mit einer Gabel das Muster eindrücken und im Salzwasser abkochen.
Äpfel schälen, reiben und mit Crème fraîche, Limonenzeste, Salz und Pfeffer abschmecken. Kalt stellen.
Den Rote-Rüben-Saft mit einem Thymian-Zweig aufkochen und reduzieren lassen. Mit Olivenöl leicht binden und eventuell mit Salz und Pfeffer abschmecken. Die Gnocchi darin schwenken. Die Steinbuttfilets würzen und in Butter mit einem Zweig Thymian braten.
Zum Anrichten die Apfel-Crème-fraîche in die Mitte des Tellers geben, die Gnocchi um die Crème fraîche platzieren und den gebratenen Steinbutt darauf anrichten.

1 lb 10 1/2 oz mealy potatoes
3 egg yolks
3 1/2 oz semolina
7 oz flour
Salt, pepper, nutmeg
2 Granny Smith apples
3 1/2 oz crème fraîche
Lemon peel, salt, pepper
1 bottle red turnip juice
1 twig thyme
3 tbsp olive oil
4 large turbot filets
2 tbsp butter
2 twigs thyme

Cook, peel and mash hot potatoes. Make a dough by adding egg yolks, semolina, flour and seasonings. Divide into evenly thick rolls, cut into 3/4 inch long pieces and shape into gnocchi. Make the pattern with a fork and cook in boiling salted water.
Peel apples, grate and mix with crème fraîche, lemon peel, salt and pepper. Chill.
Bring red turnip juice with thyme twig to a boil and reduce to 1/3. Thicken with olive oil and season with salt and pepper if needed. Combine gnocchi and reduction. Season turbot filets and fry in butter with a thyme twig.
To serve spoon the apple crème fraîche in the middle of the plate, place gnocchi around it and put turbot filet on top of it.

750 g de pommes de terre farineuses
3 jaunes d'œuf
100 g de semoule
200 g de farine
Sel, poivre, noix de muscade
2 pommes Granny Smith
100 g de crème fraîche
Zeste de citron vert, sel, poivre
1 bouteille de jus de betterave rouge
1 brin de thym
3 c. à soupe d'huile d'olive
4 grands filets de turbot
2 c. à soupe de beurre
2 brins de thym

Faire cuire les pommes de terre, les éplucher et les écraser au presse-purée tant qu'elles sont encore chaudes. Préparer une pâte en mélangeant les jaunes d'œuf, la semoule, la farine et les épices. Former des rouleaux réguliers et les couper en tronçons d'environ 2 cm de long. Façonner les gnocchi et imprimer des stries à l'aide d'une fourchette. Les mettre à cuire dans l'eau salée.
Peler les pommes, les râper et assaisonner avec la crème fraîche, le zeste de citron vert, le sel et le poivre. Réserver au froid.
Faire bouillir le jus de betterave rouge avec un brin de thym et réduire. Lier légèrement avec l'huile d'olive et, si nécessaire, rectifier l'assaisonnement. Faire sauter les gnocchi dans ce jus. Epicer les filets de turbot et les frire au beurre avec un brin de thym.
Mettre la crème fraîche à la pomme au milieu de l'assiette, disposer les gnocchi tout autour et dresser les filets de turbot par-dessus.

750 g de patatas harinosas
3 yemas de huevo
100 g de sémola
200 g de harina
Sal, pimienta, nuez moscada
2 manzanas Granny Smith
100 g de Crème fraîche
Zeste de limón, sal, pimienta
1 botella de zumo de remolacha roja
1 rama de tomillo
3 cucharadas de aceite de oliva
4 filetes de rodaballo
2 cucharadas de mantequilla
2 ramas de tomillo

Hervir las patatas, pelarlas y, todavía calientes, pasarlas por una prensa de patatas. Hacer una masa con las yemas de los huevos, la sémola, la harina y las especias. Enrollarla a rollitos uniformes de 2 cm de longitud aprox. y formar gnocchi. Imprimir el modelo con el tenedor y hervir en agua con sal.
Pelar las manzanas, rallarlas y sazonar con la Crème fraîche, el zeste del limón, sal y pimienta. Poner a enfriar.
Hervir el zumo de remolacha roja con una rama de tomillo y dejar reducir. Espesar ligeramente con el aceite de oliva y eventualmente sazonar con sal y pimienta. Sofreír dentro los gnocchi. Condimentar los filetes de rodaballo y freír en mantequilla con una rama de tomillo.
Para aderezar poner la Crème fraîche de manzana en el centro del plato, poner los gnocchi alrededor de la Crème fraîche y colocar encima el rodaballo frito.

750 g di patate farinose
3 tuorli d'uovo
100 g di semolino
200 g di farina
Sale, pepe, noce moscata
2 mele Granny Smith
100 g di crème fraîche
Scorza di lime, sale, pepe
1 bottiglia di succo di barbabietola
1 rametto di timo
3 cucchiai di olio d'oliva
4 filetti di rombo grandi
2 cucchiai di burro
2 rametti di timo

Lessate le patate, pelatele e passatele ancora bollenti in uno schiacciapatate. Fate una pasta con tuorli d'uovo, semolino, farina e spezie. Formate dei rotoli uniformi, tagliateli a tocchetti di ca. 2 cm e fate degli gnocchi. Fate passare gli gnocchi sui rebbi di una forchetta e fateli bollire in acqua salata.
Sbucciate le mele, grattugiatele e insaporitele con la crème fraîche e la scorza di lime e correggetele con sale e pepe. Mettetele a raffreddare.
Portate ad ebollizione il succo di barbabietola con un rametto di timo e fatelo ridurre. Fatelo legare leggermente con dell'olio d'oliva e correggete eventualmente con sale e pepe. Fatevi saltare gli gnocchi. Condite i filetti di rombo e friggeteli nel burro con un rametto di timo.
Guarnite mettendo la crème fraîche alle mele al centro del piatto, disponete intorno gli gnocchi e sistematevi sopra il rombo fritto.

Gaumenspiel

Design: Rodschel Rachnaev, Mario Breuer
Chef: Oliver Hoffinger, Rodschel Rachnaev

Zieglergasse 54 | 1070 Wien | 7. Bezirk
Phone: +43 1 526 11 08
www.gaumenspiel.at | essen@gaumenspiel.at
Subway: Zieglergasse
Opening hours: Mon–Fri 12 noon to 3 pm, Mon–Sat 6 pm to 12 midnight
Average price: € 27
Cuisine: Modern traditional
Special features: Reservation recommended, Gault Millau prized

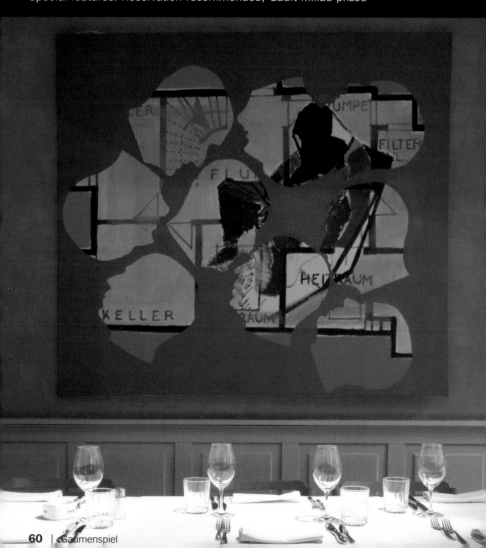

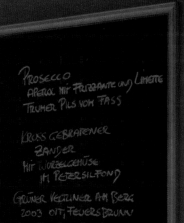

Prosecco
Aperol mit Frizzante und Limette
Trumer Pils vom Fass

Kross gebratener
Zander
mit Wurzelgemüse
im Petersilfond

Grüner Veltliner am Berg
2003 Ott, Feuersbrunn

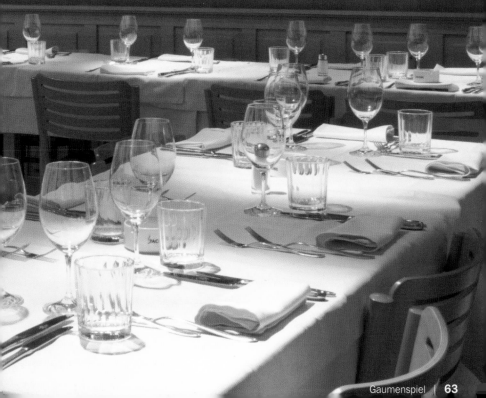

Jakobsmuscheln
mit Orangenchicorée

Great Scallops with Orange-Chicory

Coquilles Saint-Jacques et endives
à l'orange

Vieiras con endibia de naranja

Capesante con indivia belga all'arancia

2 Chicorée
100 ml Orangensaft
2 EL Zucker
2 Lorbeerblätter
3 EL Butter

8 Jakobsmuscheln (ausgelöst)
Salz, Pfeffer
Saft einer Zitrone
2 EL Butter
2 EL Olivenöl

Chicorée in Orangensaft mit Zucker und Lorbeerblättern aufkochen und 20 Minuten ziehen lassen. Chicorée vierteln und Strunk entfernen. Die einzelnen Blätter in Butter anbraten, mit Salz und Pfeffer würzen. Den Orangenfond einkochen lassen und warm halten.
Jakobsmuscheln würzen und in der Olivenöl-Butter-Mischung von jeder Seite 1 Minute braten. Chicoréeblätter auf einem Teller anrichten, die Jakobsmuscheln darauf platzieren und mit der Orangensauce und evtl. etwas Pesto garnieren.

2 chicory
100 ml orange juice
2 tbsp sugar
2 bay leaves
3 tbsp butter

8 great scallops, removed from shell
Salt, pepper
Juice of a lemon
2 tbsp butter
2 tbsp olive oil

Bring chicory in orange juice with sugar and bay leaves to a boil and let set for 20 minutes. Quarter chicory and remove stem. Fry the leaves in butter and season with salt and pepper. Reduce the orange fond and keep warm.
Season the great scallops and fry them in an olive oil/butter mix for about 1 minute on each side. Arrange chicory leaves on plates, place the great scallops on top of them and garnish with orange fond and pesto.

2 endives
100 ml de jus d'orange
2 c. à soupe de sucre
2 feuilles de laurier
3 c. à soupe de beurre

8 coquilles Saint-Jacques (décoquillées)
Sel, poivre
Jus d'un citron
2 c. à soupe de beurre
2 c. à soupe d'huile d'olive

Faire bouillir les endives dans le jus d'orange avec du sucre et des feuilles de laurier et laisser macérer 20 minutes. Couper les endives en quatre et enlever le tronc. Faire revenir les feuilles au beurre, saler et poivrer. Laisser réduire le fond et réserver au chaud.
Assaisonner les coquilles Saint-Jacques et les frire de chaque côté 1 minute dans l'huile d'olive et le beurre.
Dresser les coquilles Saint-Jacques sur un lit de feuilles d'endive. Garnir avec la sauce à l'orange et éventuellement un peu de pesto.

2 endibias
100 ml de zumo de naranja
2 cucharadas de azúcar
2 hojas de laurel
3 cucharadas de mantequilla

8 vieiras sin cáscara
Sal, pimienta
El zumo de un limón
2 cucharadas de mantequilla
2 cucharadas de aceite de oliva

Hervir la endibia en el zumo de naranja con el azúcar y las hojas de laurel y dejar reposar durante 20 minutos. Cortar la endibia a cuartos y quitar el troncho. Freír cada hoja en mantequilla, condimentar con sal y pimienta. Dejar cocer el caldo de naranja y mantener caliente.
Condimentar las vieiras y freír en la mezcla de aceite de oliva y mantequilla por cada lado durante 1 minuto.
Colocar las hojas de la endibia en un plato, poner las vieiras encima y adornar con la salsa de naranja y eventualmente con algo de pesto.

2 indivie belghe
100 ml di succo d'arancia
2 cucchiai di zucchero
2 foglie di alloro
3 cucchiai di burro

8 capesante (sgusciate)
Sale, pepe
Succo di un limone
2 cucchiai di burro
2 cucchiai di olio d'oliva

Portate ad ebollizione l'indivia belga nel succo d'arancia con lo zucchero e le foglie d'alloro e lasciatela macerare per 20 minuti. Dividete l'indivia belga in quattro porzioni ed eliminate il torsolo. Fate rosolare le singole foglie nel burro, salate e pepate. Fate ispessire il liquido d'arancia e tenetelo in caldo.
Condite le capesante e friggetele nel miscuglio di olio d'oliva e burro per 1 minuto per lato.
Mettete le foglie d'indivia belga su un piatto, disponetevi sopra le capesante e guarnite con la salsa d'arancia ed eventualmente con un po' di pesto.

Halle

Design: Eichinger oder Knechtl
Chef: Bernd Schlacher, Reinhard Wadler

Museumsplatz 1 | 1070 Wien | 7. Bezirk
Phone: +43 1 523 70 01
www.diehalle.at | halle@motto.at
Subway: Volkstheater
Opening hours: Every day 10 am to 2 am
Average price: € 20
Cuisine: Modern traditional
Special features: Young scene, terrace, internet access

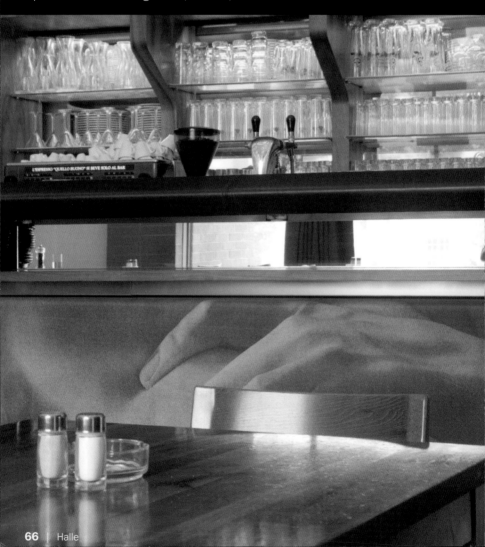

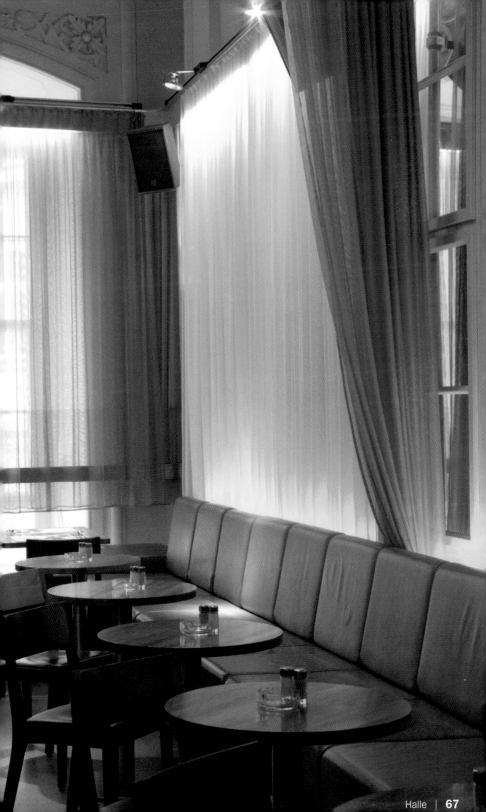

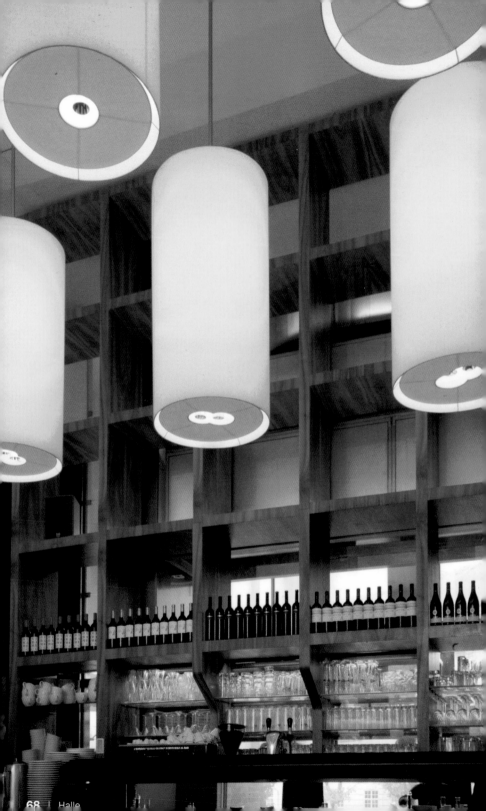

Indochine21

Design: Adrian McCarol | Chef: Wini Brugger

Stubenring 18 | 1010 Wien | 1. Bezirk
Phone: +43 1 513 76 60
www.indochine.com | restaurant@indochine.at
Subway: Stubentor
Opening hours: Every day 11:30 am to 2 am, Lunch 11:30 am to 3 pm,
Dinner 6 pm to 12 midnight
Average price: € 20
Cuisine: French, Indochine
Special features: Kid-friendly, private rooms, Gault Millau prized

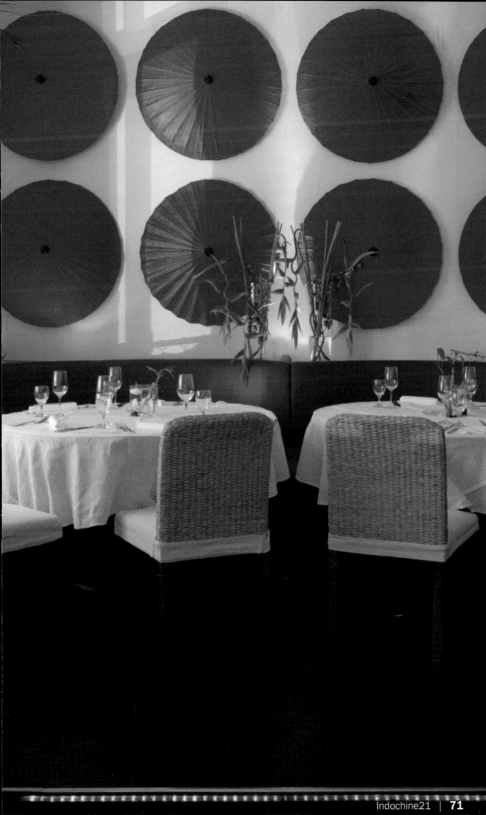

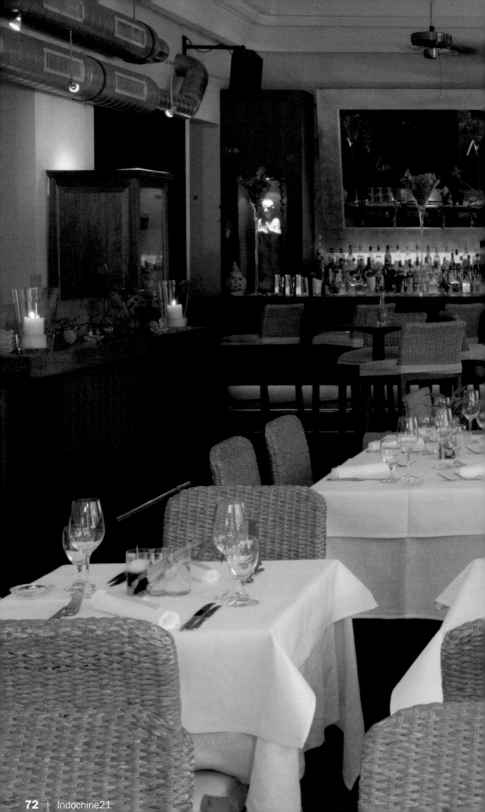

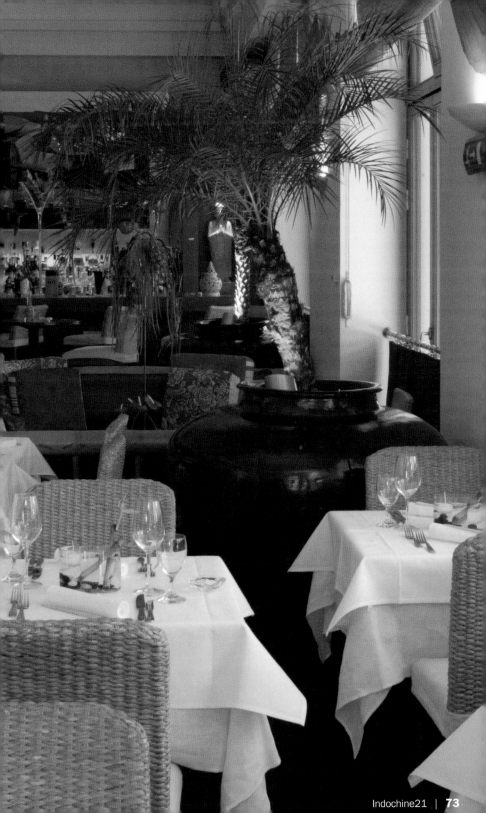

Roter Snapper

in Sesamkruste mit Pak-Choi und Mango-Chutney

Red Snapper in Sesame Crust with
Pak-Choy and Mango-Chutney

Vivaneau en croûte de sésame, pak-choi
et chutney à la mangue

Filete de chillo en costra de sésamo con
pak-choi y chutney de mango

Snapper rosso in crosta di sesamo con
pak choi e mango chutney

4 rote Snapperfilets à 150 g, entgrätet
und geputzt
100 g Sesamblätterteig
1 Ei
200 g Pak-Choi
2 EL Sesamöl
2 EL Sojasauce
150 g Mangofleisch
50 g Palmzucker
125 ml Weinessig
20 g Chilis, gehackt
10 g Korianderblätter
10 g Basilikum
Meersalz
Evtl. Maisstärke

Den Sesamblätterteig dünn ausrollen und netz-
artig einschneiden. Die Fischfilets würzen, in den
Teig einwickeln, mit verquirltem Ei bestreichen
und im Ofen 8 Minuten bei 180 °C backen.
Das Pak-Choi im Wok kurz dünsten und mit etwas
Sojasauce abschmecken.
Die Mangos klein schneiden und mit Palmzucker,
Weinessig und gehackten Chilis kurz aufkochen.
Quellen lassen und mit Koriander, Basilikum
und Meersalz abschmecken. Eventuell mit etwas
Maisstärke abbinden.
Den fertig gebackenen Fisch auf dem Pak-Choi
anrichten und mit dem Mango-Chutney vollen-
den. Rasch servieren.

4 red snapper filets, 5 oz each, cleaned
and deboned
3 1/2 oz sesame flaky pastry
1 egg
7 oz pak-choy
2 tbsp sesame oil
2 tbsp soy sauce
5 oz mango
1 3/4 oz palm sugar
125 ml wine vinegar
1 oz chillis, chopped
1/2 oz cilantro leaves
1/2 oz basil leaves
Sea salt
Corn starch as needed

Roll out flaky pastry medium thin and cut a net-
shaped pattern in it. Season fish filets, wrap in
pastry, spread with beaten egg and bake in a
360 °F oven for 8 minutes.
Sauté pak-choy in a wok and season with soy
sauce.
Cut up mango and bring to a boil with palm sugar,
wine vinegar and chillis. Reduce heat and season
with cilantro, basil and sea salt. Thicken with corn
starch, if needed.
Place the baked fish on the pak-choy and finish
with mango-chutney. Serve immediately.

4 filets de vivaneau à 150 g, lavés et sans
arêtes
100 g de pâte feuilletée au sésame
1 œuf
200 g de pak-choi
2 c. à soupe d'huile de sésame
2 c. à soupe de sauce de soja
150 g de chair de mangue
50 g de sucre de palmier
125 ml de vinaigre de vin
20 g de chili haché
10 g de feuille de coriandre
10 g de basilic
Sel marin
Eventuellement de la fécule de maïs

Abaisser une mince couche de pâte feuilletée et
tracer au couteau un quadrillage. Assaisonner
les filets de poisson, les rouler dans la pâte, les
badigeonner avec l'œuf battu et les enfourner à
180 °C pendant 8 minutes.
Etuver brièvement le pak-choi et assaisonner
avec un peu de sauce de soja.
Couper les mangues en petits morceaux et les
faire bouillir brièvement avec le sucre de palmier,
le vinaigre de vin et le chili haché. Laisser gonfler
et assaisonner avec la coriandre, le basilic et le
sel marin. Eventuellement, rajouter de la fécule
de maïs pour lier.
Dresser le poisson cuit sur le pak-choi et garnir
avec le chutney à la mangue. Servir rapidement.

4 filetes de chillo de 150 g cada uno, sin espinas
y limpios
100 g de hojaldre de sésamo
1 huevo
200 g de pak-choi
2 cucharadas de aceite de sésamo
2 cucharadas de salsa de soja
150 g de pulpa de mango
50 g de azúcar de palma
125 ml de vinagre
20 g de chiles, picados
10 g de hojas de cilantro
10 g de albahaca
Sal marina
Eventualmente fécula de maíz

Extender con el rodillo el hojaldre de sésamo
finamente y hacer cortes en forma de retículas.
Condimentar los filetes de pescado, envolver en
la masa, untar con el huevo batido y asarlos en
el horno durante 8 minutos a 180 °C.
Rehogar brevemente el pak-choi en el wok y sa-
zonar con algo de salsa de soja.
Cortar los mangos a trozos pequeños y hervir
brevemente con el azúcar de palma, el vinagre y
los chiles picados.
Dejar en remojo y sazonar con el cilantro, la alba-
haca y la sal marina. Eventualmente, espesar con
algo de fécula de maíz.
Colocar el pescado ya asado sobre el pak-choi
y completar con el chutney de mango. Servir
rápidamente.

4 filetti di snapper rosso da 150 g spinato
e pulito
100 g di pasta sfoglia al sesamo
1 uovo
200 g di pak choi
2 cucchiai di olio di sesamo
2 cucchiai di salsa di soia
150 g di polpa di mango
50 g di zucchero di palma
125 ml di aceto di vino
20 g di chili tritato
10 g di foglie di coriandolo
10 g di basilico
Sale marino
Eventualmente amido di mais

Spianate la pasta sfoglia al sesamo in modo
sottile e incidetela a mo' di reticolo. Condite i
filetti di pesce, avvolgeteli nella pasta, spalmatevi
sopra l'uovo sbattuto e fateli cuocere in forno per
8 minuti a 180 °C.
Nel wok fate cuocere al vapore il pak choi e insa-
porite con un po' di salsa di soia.
Tagliate il mango a pezzetti e fatelo bollire con lo
zucchero di palma, l'aceto di vino e il chili tritato.
Lasciate macerare e correggete con coriandolo,
basilico e sale marino. Eventualmente fate legare
il tutto con un po' di amido di mais.
Mettete sul pak choi il pesce cotto in forno e
completate con il mango chutney. Servite ancora
caldo.

Kim kocht

Design: Sohyi Kim | Chef: Sohyi Kim

Lustkandlgasse 6 | 1090 Wien | 9. Bezirk
Phone: +43 1 319 02 42
www.kimkocht.at | restaurant@kimkocht.at
Subway: Währinger Straße – Volksoper
Opening hours: Wed–Fri 6 pm to 12 midnight
Average price: € 39
Cuisine: Modern Japanese with Austrian influence, Fusion
Special features: Reservation essential, cookery courses, Gault Millau prized

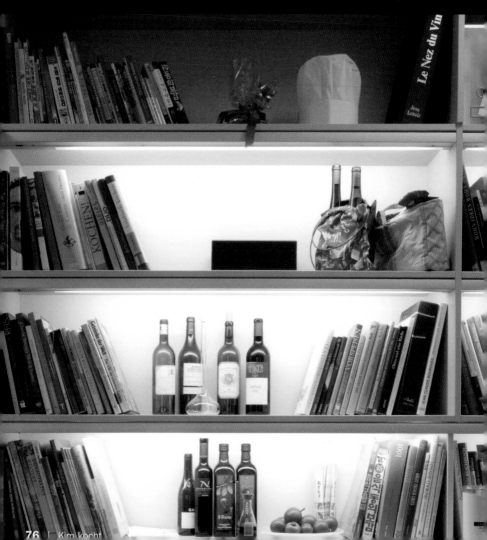

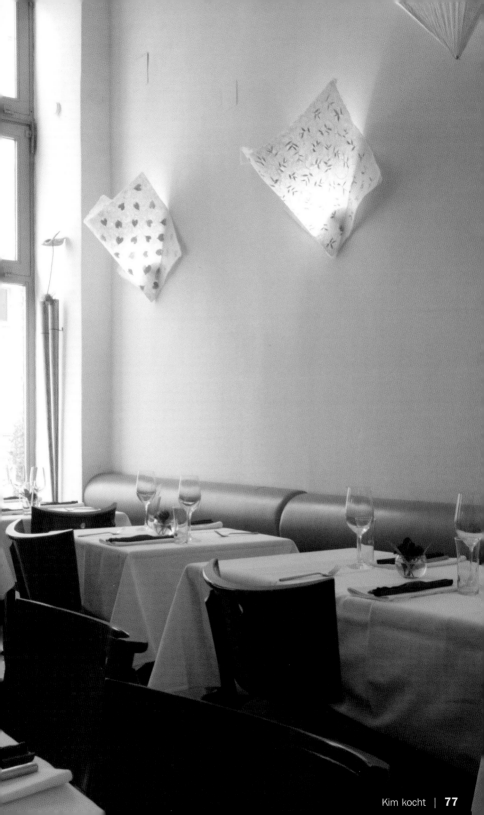

Gebratener Thunfisch

im Reisblättermantel mit Rosmarinpesto und Gnocchi

Fried Thuna in Rice-Leaf Coat with Rosemary-Pesto and Gnocchi

Roulé de feuilles de riz au thon avec pesto au romarin et gnocchi

Atún frito en manto de hojas de arroz con pesto de romero con gnocchi

Tonno fritto in manto di fogli di riso con pesto al rosmarino e gnocchi

1 Bund Rosmarin
Olivenöl zum Frittieren
1 Knoblauchzehe
100 g geröstete Pinienkerne
2 EL Parmesan, gerieben

500 g mehlige Kartoffeln
1 Prise Muskatnuss, Salz
3 Eigelbe
3–4 EL Mehl
4 Thunfischfilets à 50 g
4 Reisblätter, eingeweicht
Salz, Pfeffer

Die Rosmarinnadeln abzupfen. Das Olivenöl in einer Pfanne erhitzen und den Rosmarin darin knusprig frittieren (Achtung: geht sehr schnell!). In ein Sieb geben und abtropfen lassen. Öl zum Erkalten zur Seite stellen. Knoblauch schälen und fein hacken. Frittierten Rosmarin, Pinienkerne, Knoblauch und 1 EL erkaltetes Oliven-Rosmarinöl in einem Mixer zu einer festen Masse pürieren.

Zum Schluss Parmesan vorsichtig einrühren. Kartoffeln weich kochen und schälen. Noch heiß mit der Kartoffelpresse zerdrücken, abkühlen lassen. Mit Muskatnuss und Salz würzen. Eigelbe und Mehl einarbeiten und zu einem weichen Kartoffelteig kneten. Teig vierteln und jeweils zu 2 cm dicken Rollen formen. Rollen in 2 cm lange Stücke schneiden und zu Gnocchi rollen. In einem großen Topf Salzwasser aufkochen, Gnocchi hineingeben und so lange garen, bis sie auf der Wasseroberfläche schwimmen.
Thunfischfilets würzen und kurz anbraten, etwas Pesto auf die Reisblätter geben, die Thunfischfilets darin einwickeln und aufeinander stapeln. Mit den Gnocchi und dem restlichen Pesto anrichten.

1 bunch rosemary
Olive oil for deep-frying
1 glove garlic
3 1/2 oz roasted pine nuts
2 tbsp parmesan cheese

18 oz mealy potatoes
1 pinch nutmeg, salt
3 egg yolks
3–4 tbsp flour
4 slices thuna, 2 oz each
4 rice leaves, soaked
Salt, pepper

Remove rosemary needles from twigs. Heat up oil in a pan and fry rosemary until crispy (Attention: burns very fast!). Pour through a strainer. Set oil aside to chill. Peel garlic and chop very finely. Combine fried rosemary needles, pine nuts, garlic and 1 tbsp chilled rosemary oil in a blender and mix until smooth. At last add parmesan cheese and fold under carefully.
Cook potatoes until tender and peel. Mash potatoes and let cool. Season with salt and nutmeg. Mix with egg yolks and flour to make a soft dough. Seperate dough into 4 pieces and make a 3/4 inch thick roll. Cut each roll into 3/4 inch long pieces and shape into a gnocchi. Bring salted water in a big pot to a boil and cook gnocchi until they rise to the surface.
Season thuna filets and fry very quickly, spoon a little amount of pesto on the rice leaves and wrap the thuna filets in it. Stack on top of each other. Finish with the gnocchi and the left pesto.

1 bouquet de romarin
Huile d'olive à frire
1 gousse d'ail
100 g de pignons grillés
2 c. à soupe de parmesan râpé

500 g de pommes de terre farineuses
1 pincée de noix de muscade, sel
3 jaunes d'œuf
3–4 c. à soupe de farine
4 filets de thon à 50 g
4 feuilles de riz humidifiées
Sel, poivre

Détacher les aiguilles de romarin. Chauffer l'huile d'olive dans une poêle et frire le romarin jusqu'à ce qu'il soit croustillant (attention : cela va très vite). Tamiser et laisser égoutter. Laisser refroidir l'huile. Eplucher l'ail et hacher finement. Passer au mixeur le romarin frit, les pignons, l'ail et 1 c. d'huile d'olive refroidie pour obtenir une ， compacte. Ajouter délicatement le parmesan. Faire cuire les pommes de terre et les éplucheい. Ecraser les pommes de terre chaudes au presse-purée. Laisser refroidir. Assaisonner avec la noix de muscade et le sel. Incorporer les jaunes d'œuf et la farine et pétrir jusqu'à obtenir une pâte molle. Couper la pâte en quatre et former des rouleaux de 2 cm de diamètre. Couper les rouleaux en tronçons de 2 cm et façonner les gnocchi. Faire bouillir de l'eau salée dans une grande marmite, y plonger les gnocchi et les laisser cuire jusqu'à ce qu'ils remontent à la surface. Assaisonner les filets de thon et les faire revenir brièvement. Les envelopper dans les feuilles de riz avec un peu de pesto au romarin. Empiler les feuilles farcies et dresser les gnocchi avec le reste du pesto au romarin.

1 manojo de romero
Aceite de oliva para freír
1 diente de ajo
100 g de piñones tostados
2 cucharadas de parmesano, rallado

500 g de patatas harinosas
1 pizca de nuez moscada
3 yemas de huevo, sal
3–4 cucharadas de harina
4 filetes de atún de 50 g cada uno
4 hojas de arroz, puestas a remojo
Sal, pimienta

Arrancar las agujas de romero. Calentar el aceite de oliva en una sartén y freír en él el romero hasta que esté crujiente. (Cuidado: ¡ocurre muy rápidamente!). Poner en un colador y dejar escurrir. Poner el aceite aparte para que se enfríe. Pelar el ajo y picarlo fino. En la batidora hacer un puré con el romero frito, los piñones, el ajo y 1 cucharada del aceite de oliva de freír el romero una vez enfriado. Al final mezclar el parmesano con cuidado. Hervir las patatas hasta que estén blandas y pelarlas. Prensarlas todavía calientes con la prensa para patatas, dejar enfriar. Condimentar con nuez moscada y sal. Introducir las yemas de los huevos y la harina y amasar hasta formar una masa de patatas blanda. Cortar la masa en cuatro partes y formar rollos de 2 cm de grosor respectivamente. Cortar los rollos a trozos de 2 cm de longitud y enrollar haciendo gnocchi. Hervir agua con sal en una olla grande, echar los gnocchi y cocer hasta que estos floten sobre la superficie del agua. Condimentar los filetes de atún y freír brevemente, poner algo del pesto sobre las hojas de arroz, envolver en ellas los filetes de atún y apilarlos unos sobre otros. Aderezar con los gnocchi y el resto del pesto.

1 mazzetto di rosmarino
Olio d'oliva per friggere
1 spicchio d'aglio
100 g di pinoli tostati
2 cucchiai di parmigiano grattugiato

500 g di patate farinose
1 pizzico di noce moscata, sale
3 tuorli d'uovo
3–4 cucchiai di farina
4 filetti di tonno da 50 g
4 fogli di riso ammorbiditi
Sale, pepe

Staccate gli aghi di rosmarino. In una padelle scaldate l'olio d'oliva e friggetevi il rosmarino finché diventerà croccante (attenzione: ci vuole pochissimo tempo!). Versatelo in un colino e lasciatelo sgocciolare. Fate raffreddare l'olio da una parte. Sbucciate l'aglio e tritatelo finemente. Frullate in un frullatore il rosmarino fritto, i pinoli, l'aglio e un 1 cucchiaio dell'olio d'oliva in cui è stato fritto il rosmarino fino ad ottenere una massa solida. Infine incorporate con cautela il parmigiano. Lessate bene le patate e pelatele. Schiacciatele ancora calde con lo schiacciapatate, lasciatele raffreddare. Insaporite con la noce moscata e il sale. Aggiungete i tuorli d'uovo e la farina e impastate il tutto fino ad ottenere una pasta di patate morbida. Dividete la pasta in quattro porzioni e formate quattro rotoli dello spessore di 2 cm ciascuno. Tagliate i rotoli a tocchetti di 2 cm e fateli girare formando degli gnocchi. In un tegame grande fate bollire dell'acqua salata, versatevi gli gnocchi e fateli cuocere finché verranno a galla. Condite i filetti di tonno e fateli rosolare per qualche istante, mettete un po' di pesto sui fogli di riso, avvolgetevi i filetti di tonno e sovrapponeteli. Guarnite con gli gnocchi e il pesto rimasto.

s American Bar

olf Loos | Chef: Marianne Kohn

Kärntner Durchgang 10 | 1010 Wien | 1. Bezirk
Phone: +43 1 512 32 83
www.loosbar.at | office@loosbar.at
Subway: Stephansplatz
Opening hours: Thu–Sat 12 noon to 5 pm, Sun–Wed 12 noon to 4 pm
Average price: € 8
Special features: Drinks only

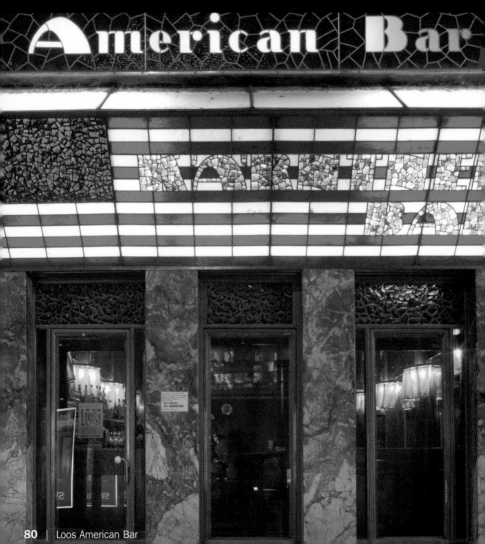

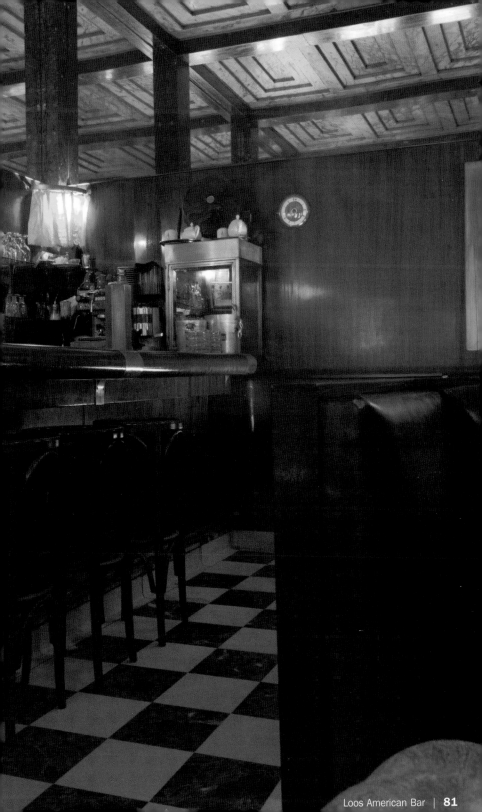

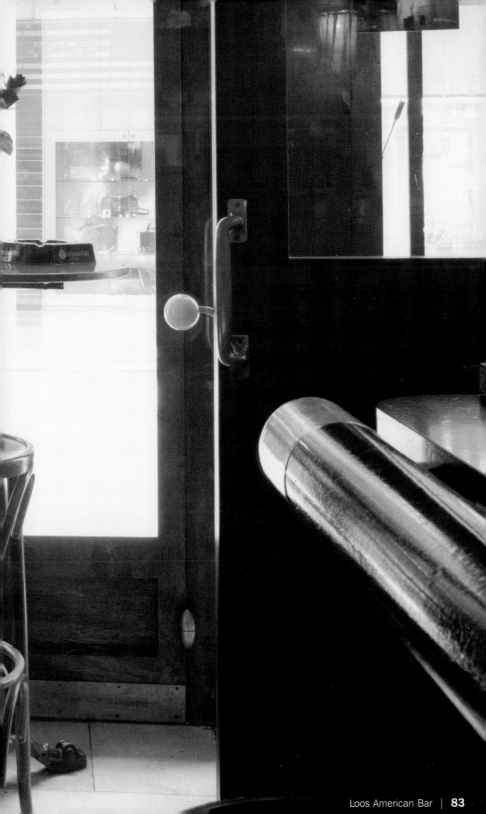

MAK Café

Design: Hermann Czech

Stubenring 5 | 1010 Wien | 1. Bezirk
Phone: +43 1 714 01 21
www.mak.at
Subway: Stubentor, Landstraße
Opening hours: Tue–Sun 10 am to 2 am, closed on Monday
Average price: € 10
Cuisine: International
Special features: Celeb hangout, patio

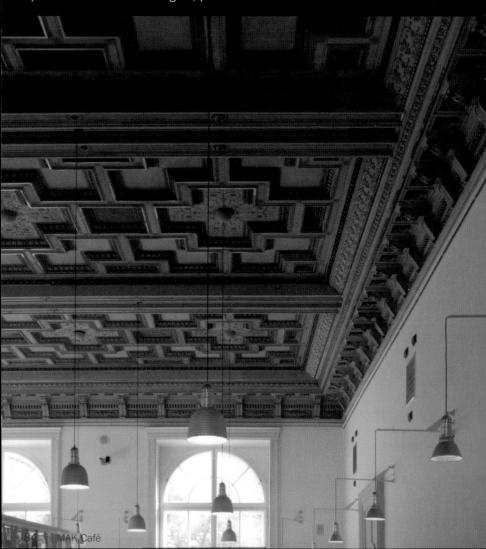

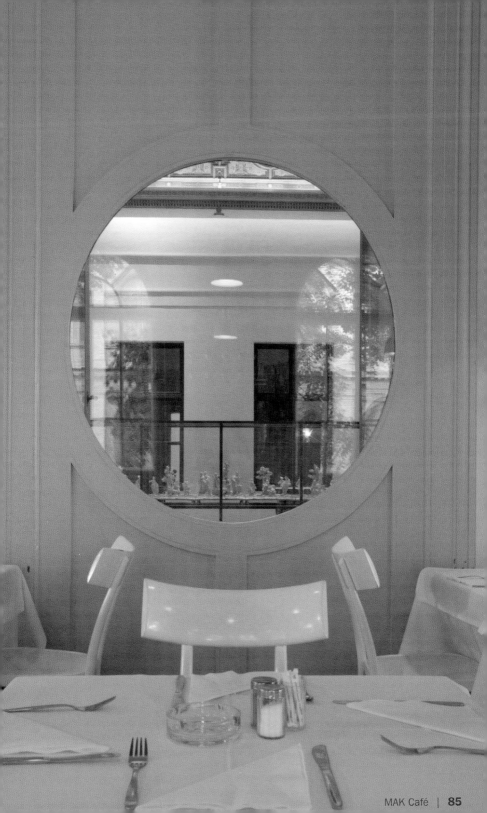

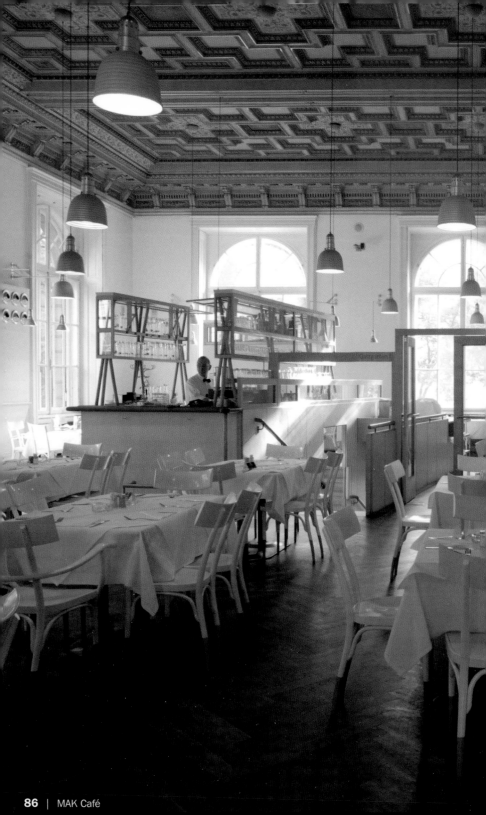

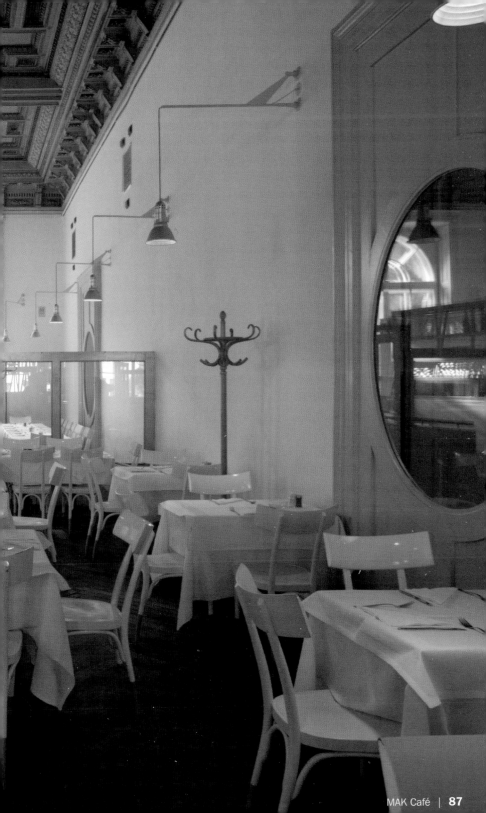

Meinl am Graben

Design: Otto Rau | Chef: Joachim Gradwohl

Graben 19 | 1010 Wien | 1. Bezirk
Phone: +43 1 532 33 34 60 00
www.meinlamgraben.at | restaurant@julius.meinl.com
Subway: Stephansplatz, Herrengasse
Opening hours: Mon–Wed 8:30 to 12 midnight, Thu–Fri 8 am to 12 midnight,
Sat 9 am to 12 midnight, closed on Sunday
Average price: € 55
Cuisine: International
Special features: Delicatessen, private rooms, Gault Millau prized

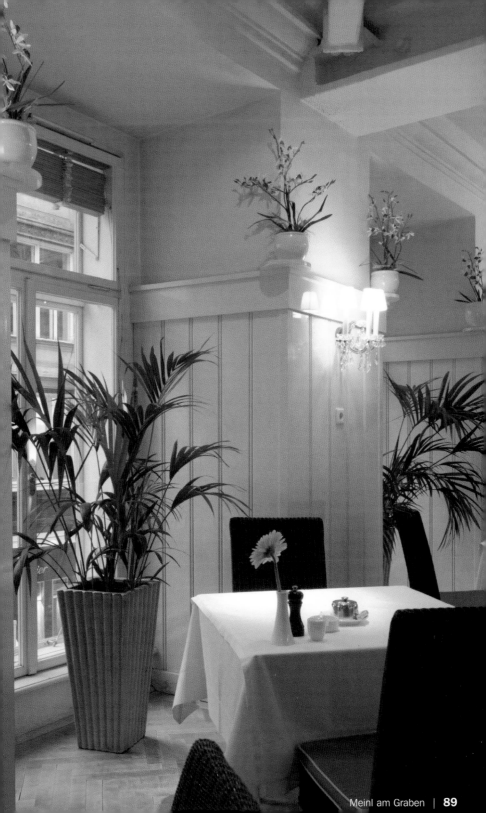

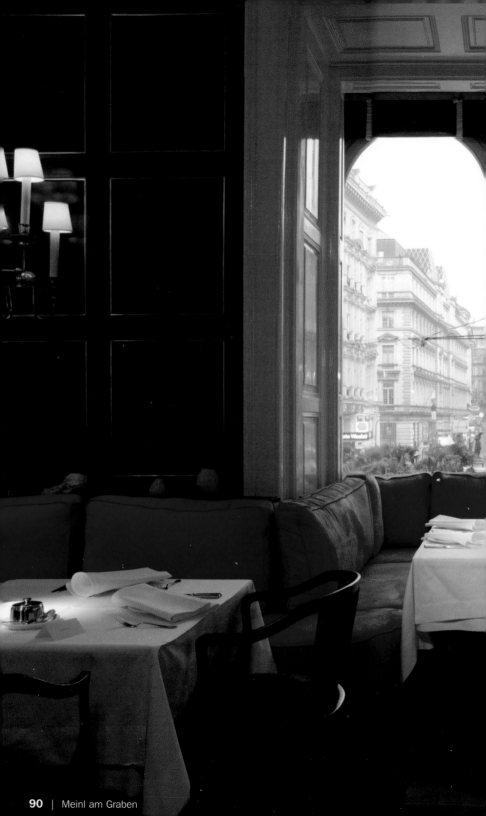

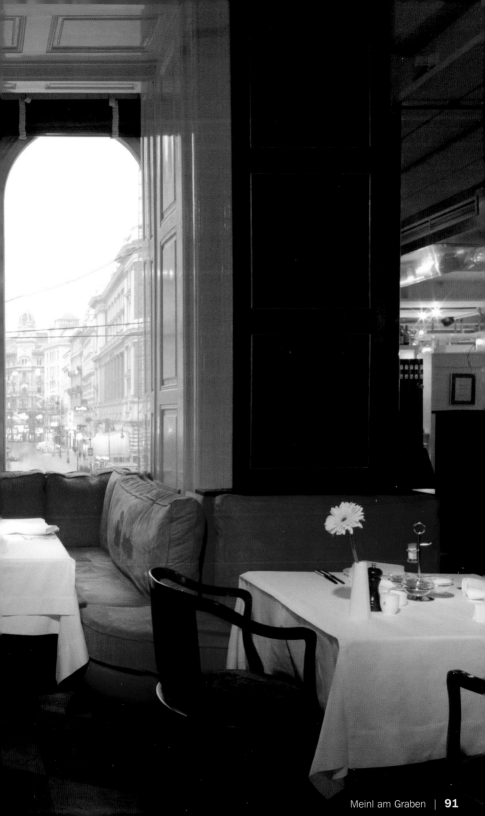

Mole West

Design: Herbert Halbritter | Chef: Wolfgang Ensbacher

Strandbad-Westmole | 7100 Neusiedl am See
Phone: +43 2 16 72 02 05
www.mole-west.at | office@mole-west.at
Opening hours: May–September every day 9 am to 12 midnight
Average price: € 12
Cuisine: International
Special features: Outdoor dining, sea terrace

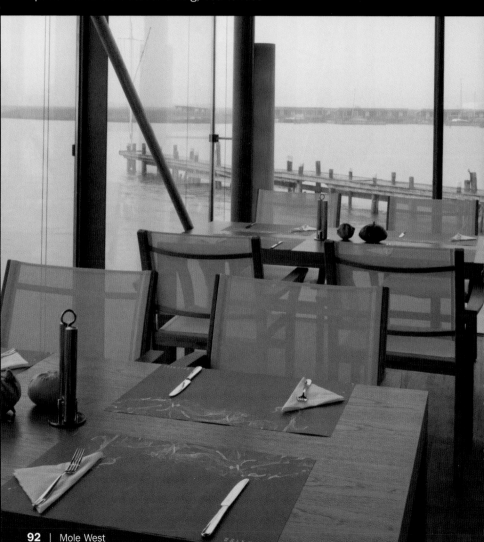

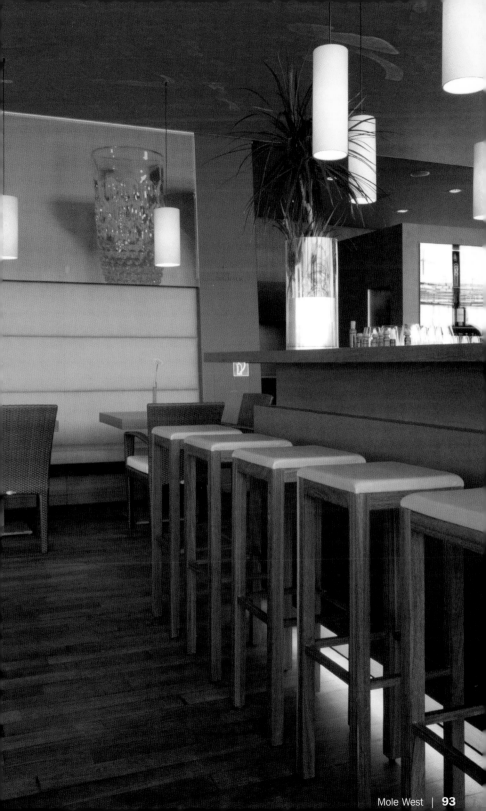

Kürbispralinen
auf Süßweinschaum

Pumpkin Pralinee on Sweet Wine Cream

Pralines au potiron sur mousse au vin

Bombones de calabaza en espuma de vino dulce

Praline di zucca su spuma di vino dolce

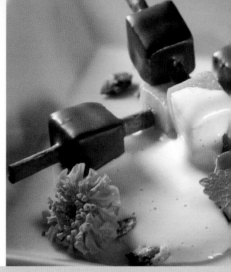

600 g Stangen- oder Muskatkürbis
8 Zimtstangen (lang und dünn)
500 ml Süßwein
150 g Zucker
2 EL Zitronensaft
100 g Milchschokolade
100 g Zartbitterschokolade
3 Eigelbe
Minzblätter, Essblüten und dragierte Kürbiskerne zum Verzieren

Kürbis schälen und in 24 2 x 2 cm große Würfel schneiden. Je 3 Würfel vorsichtig auf eine Zimtstange aufspießen. Wenn die Zimtstangen zu dick sind, kann man versuchen, sie der Länge nach zu brechen.
Süßwein, Zucker und etwas Zitronensaft in einen Topf geben und aufkochen. Zurückschalten und die Zimt-Kürbisspieße bei schwacher Hitze 20 Minuten ziehen lassen. Vom Herd nehmen und abdecken. Bei Zimmertemperatur ca. 2 Stunden lang durchziehen lassen.

Zimtspieße aus der Marinade nehmen und gut abtropfen lassen. Eventuell mit Küchenpapier trocken tupfen und kurz in den Kühlschrank stellen.
Helle und dunkle Kuvertüre getrennt voneinander über einem Wasserbad schmelzen. Die Hälfte der Spieße mit heller Kuvertüre und die andere Hälfte mit dunkler Kuvertüre unter ständigem Drehen glasieren. Dabei immer den mittleren Kürbiswürfel freilassen. Auf ein Abtropfgitter legen und kalt stellen.
Eigelbe und die Hälfte der Süßweinmarinade in einen Rundkessel geben und über heißem Wasserbad schaumig schlagen.
Je zwei Spieße über Kreuz auf einen Teller legen und mit Süßweinschaum garnieren. Mit Minze, Essblüten und Kürbiskernen verzieren.

1 lb 5 oz calabash pumpkin
8 cinnamon sticks (long and thin)
500 ml sweet wine
5 oz sugar
2 tbsp lemon juice
3 1/2 oz milk chocolate
3 1/2 oz semi-sweet chocolate
3 egg yolks
Mint leaves, decoration flowers and candy pumpkin seeds for decoration

Peel pumpkin and cut into 24 3/4 x 3/4 inch big cubes. Carefully spear 3 cubes on one cinnamon stick. If the cinnamon sticks are too thick, you can try to cut them in half lengthwise.
Combine sweet wine, sugar and lemon juice in a pot and bring to a boil. Reduce the heat and let the pumpkin-cinnamon sticks simmer for 20 minutes. Take off the stove and marinate at room temperature for 2 hours.

Remove sticks from the marinade and dry off very well. If needed dry off with a paper towel and place in the fridge.
Melt both kinds of chocolate separately in double boilers. Cover one half of the pumpkin cubes with milk chocolate, the other half with dark chocolate, but always leave the middle cube free. Turn constantly. Place on a rost and chill.
Combine egg yolks and half of the sweet wine marinade in a bowl and whisk over a boiling water pot until it gets thick and creamy.
Place two sticks on top of each other and garnish with sweet wine cream. Decorate with mint leaves, flowers and pumpkin seeds.

600 g de potiron (p. ex. Muscade de Provence)
8 bâtons de cannelle (longs et minces)
500 ml de vin sucré
150 g de sucre
2 c. à soupe de jus de citron
100 g de chocolat au lait
100 g de chocolat noir
3 jaunes d'œuf
Feuilles de menthe, fleurs comestibles et graines de potiron dragéifiées pour la décoration

Eplucher les potirons et couper 24 dés de 2 x 2 cm. Enfiler délicatement trois dés sur chaque bâton de cannelle. Si les bâtons sont trop gros, essayer de les partager dans le sens de la longueur.
Faire bouillir le vin, le sucre et un peu de jus de citron dans une casserole. Baisser la température et y mettre les brochettes. Laisser cuire à petit feu pendant 20 minutes. Retirer du feu et couvrir.

Faire mariner environ 2 heures à la température ambiante.
Sortir les brochettes de la marinade et bien laisser égoutter. Eventuellement, sécher avec du papier absorbant et mettre brièvement au réfrigérateur.
Faire fondre séparément au bain-marie les couvertures claire et foncée. Tourner sans s'arrêter les brochettes dans le chocolat fondu. Une moitié des brochettes aura une couverture claire et l'autre moitié, une couverture foncée. Laisser le dé du milieu sans couverture. Déposer sur un égouttoir et réserver au froid.
Mettre les jaunes d'œuf et la moitié de la marinade au vin dans une terrine et battre en mousse au-dessus d'un bain-marie chaud.
Disposer les brochettes en croix sur une assiette et garnir avec la mousse au vin. Décorer avec la menthe, les fleurs et les graines de potiron.

600 g de calabaza de palo o calabaza moscada
8 palos de canela (largos y delgados)
500 ml de vino dulce
150 g de azúcar
2 cucharadas de zumo de limón
100 g de chocolate con leche
100 g de chocolate amargo
3 yemas de huevo
Hojas de menta, brotes comestibles y pepitas de calabaza con una cobertura para adornar

Pelar la calabaza y cortar en 24 dados de 2 x 2 cm. Pinchar cuidadosamente cada 3 dados en un palo de canela. Si los palos de canela son demasiado gruesos puede intentarse romperlos a lo largo.
Poner en una olla y hervir el vino dulce, el azúcar y algo del zumo del limón. Bajar el fuego y dejar reposar a fuego lento los pinchos de canela con la calabaza durante 20 minutos. Retirar del fuego y tapar. Dejar reposar durante unas dos horas a temperatura ambiente.

Sacar los pinchos de canela de la marinada y escurrir bien. Eventualmente secar un poco con papel de cocina y ponerlos en la nevera brevemente.
Derretir al baño María la cobertura clara y la oscura por separado. Glasear la mitad de los pinchos con la cobertura clara y la otra mitad con la cobertura oscura dándoles vueltas constantemente dejando libre el dado de calabaza en el centro. Poner en un escurridor y enfriar.
Poner las yemas de huevo y la mitad de la marinada de vino dulce en una olla redonda y batir sobre un baño María caliente hasta hacer espuma.
Poner en cruz cada dos pinchos en un plato y adornar con la espuma de vino dulce. Aderezar con la menta, los brotes comestibles y las pepitas de calabaza.

600 g di zucca di Napoli o zucca moscata
8 bastoncini di cannella (lunghi e sottili)
500 ml di vino dolce
150 g di zucchero
2 cucchiai di succo di limone
100 g di cioccolato al latte
100 g di cioccolato semifondente
3 tuorli d'uovo
Foglie di menta, fiori commestibili e semi di zucca confettati per decorare

Pelate la zucca e tagliatela in 24 dadi di 2 x 2 cm. In ogni bastoncino di cannella infilate con cautela 3 dadi. Se i bastoncini sono troppo grossi, si può cercare di spezzarli a metà nel senso della lunghezza.
In un tegame mettete il vino dolce, lo zucchero e un po' di succo di limone e portate ad ebollizione. Abbassate quindi la fiamma e lasciatevi macerare per 20 minuti gli spiedini di cannella e

zucca a fuoco moderato. Toglieteli dal fornello e copriteli. Fateli marinare per 2 ore a temperatura ambiente.
Togliete gli spiedini di cannella dalla marinata e fateli sgocciolare bene. Eventualmente asciugateli, picchiettandoli con carta assorbente da cucina e metteteli per qualche istante in frigorifero.
Sciogliete separatamente il cioccolato da copertura chiaro e scuro su un bagnomaria. Glassate la metà degli spiedini con la glassa chiara e l'altra metà con la glassa scura, girandoli continuamente e lasciando sempre scoperto il dado di zucca centrale. Fateli sgocciolare su una griglia e fateli raffreddare.
In un paiolo rotondo versate i tuorli d'uovo e metà della marinata di vino dolce e montateli su un bagnomaria bollente.
Su ogni piatto mettete due piedini incrociati e guarnite con spuma di vino dolce. Decorate con menta, fiori commestibili e semi di zucca.

Onyx Bar

Design: Hans Hollein | Chef: Attila Dogudans

Stephansplatz 12 / Haas-Haus | 1010 Wien | 1. Bezirk
Phone: +43 1 535 39 69
www.doco.com | onyx@doco.com
Subway: Stephansplatz
Opening hours: Every day 9 am to 2 am
Average price: € 25
Cuisine: Contemporary
Special features: Breakfast, terrace, bar scene, wonderful view

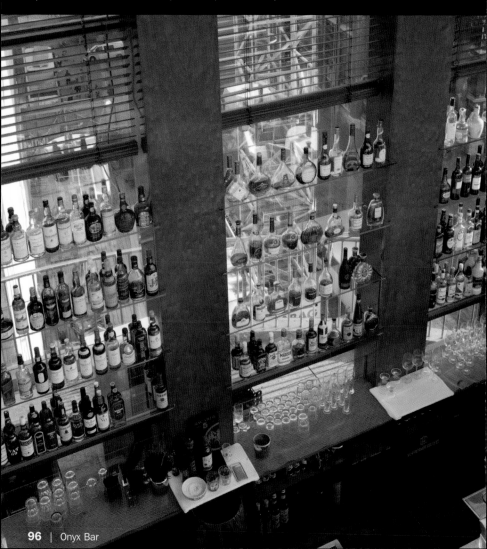

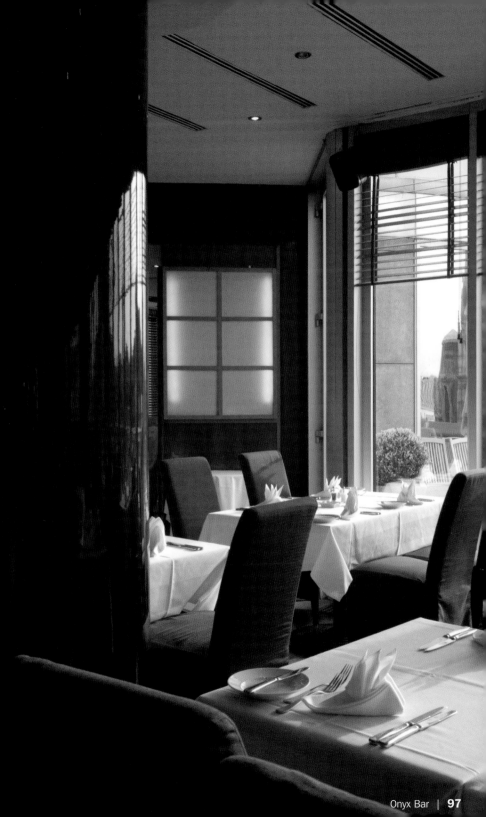

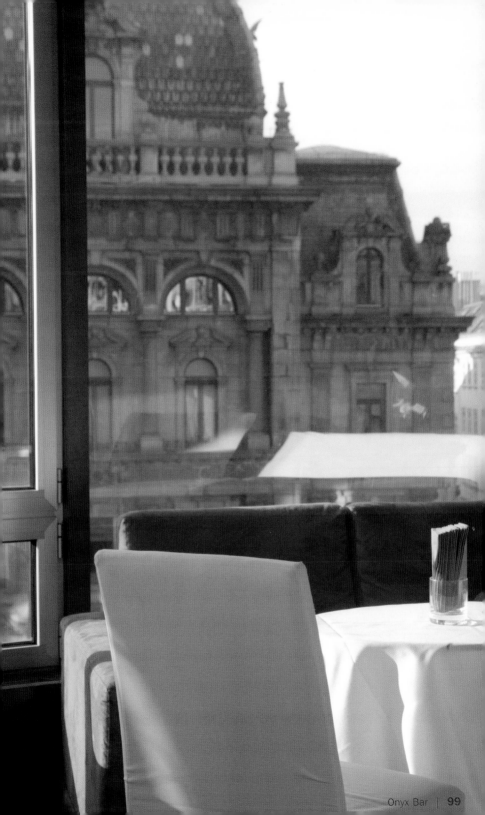

Oswald & Kalb Restaurant

Design: The unit architects | Chef: Marinko Dragusica

Bäckerstraße 14 | 1010 Wien | 1. Bezirk
Phone: +43 1 512 13 71
o-k@utanet.at
Subway: Stubentor
Opening hours: Every day 6 pm to 2 am
Average price: € 25
Cuisine: Classical Austrian
Special features: Reservation recommended, large cigar assortment

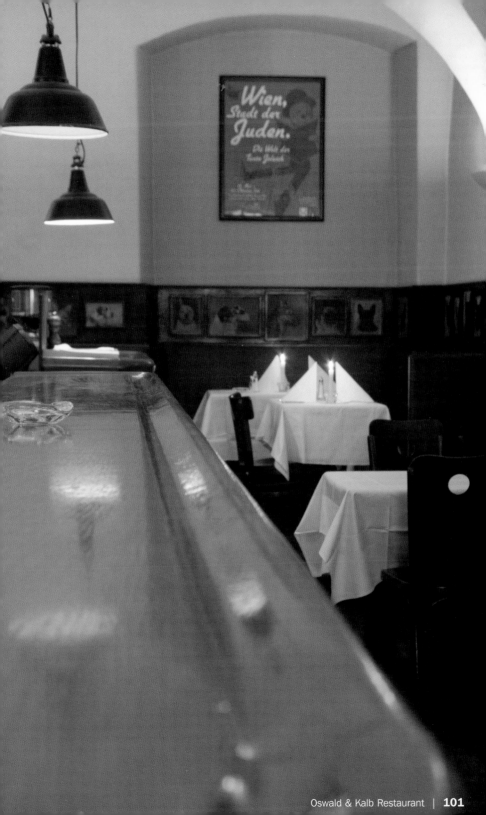

Carpaccio

vom Hirschrücken mit Szechuan-pfeffer und sautierten Steinpilzen

Carpaccio of Deer Filet with Szechuan pepper and sauteed Edible Boletus

Carpaccio de selle de cerf au poivre de Sichuan et cèpes sautés

Carpaccio de espalda de venado con pimiento de Szechuan y boletos salteados

Carpaccio di lombo di cervo con frassino spinoso e porcini saltati

1 Hirschrückenfilet ca. 800 g

2 EL Butter
300 g Steinpilze, geputzt und halbiert
2 Schalotten, gewürfelt
2 Knoblauchzehen, gehackt
2 Tomaten, geschält und gewürfelt
2 EL Petersilie, gehackt
Saft einer Zitrone
Olivenöl
Salz, Pfeffer

450 g Rucola, geputzt und gewaschen
90 ml weißer Balsamicoessig
200 ml Nussöl
Meersalz
Szechuanpfeffer aus der Mühle

Das Hirschfilet sauber putzen und ca. 30 Minuten einfrieren.
Butter in einer Pfanne erhitzen und die Pilze mit Schalotten und Knoblauch sautieren. Tomatenwürfel zugeben, mit Salz und Pfeffer würzen und mit Olivenöl, Zitronensaft und Petersilie marinieren. Beiseite stellen.
Das angefrorene Hirschfilet mit einem scharfen Messer in sehr dünne Scheiben schneiden und auf einem mit Nussöl eingepinselten Teller gleichmäßig verteilen. Den geputzten Rucolasalat mit dem Essig und dem restlichen Öl marinieren und in der Mitte des Carpaccios platzieren. Die lauwarmen Pilze darum verteilen und mit Meersalz und Szechuanpfeffer aus der Mühle verfeinern.

1 deer filet, approx. 1 3/4 lb

2 tbsp butter
9 1/2 oz edible boletus, cleaned and cut lengthwise
2 shallots, diced
2 gloves garlic, chopped
2 tomatoes, peeled and diced
2 tbsp parsley, chopped
Juice of a lemon
Olive oil
Salt, pepper

1 lb rucola, cleaned and washed
90 ml white balsamic vinegar
200 ml nut oil
Sea salt
Szechuan pepper from the mill

Remove the fat and tough parts from the deer filet and place in the freezer for 30 minutes.
Melt butter in a pan and sauté mushrooms, shallots and garlic. Add tomato cubes, season with salt and pepper and marinate with olive oil, lemon juice and parsley. Set aside.
Cut the half-frozen deer filet with a sharp knife in very thin slices and spread evenly on a plate that is brushed with nut oil. Marinate the rucola salad with the vinegar and left nut oil and place in the middle of the carpaccio. Spread the mushrooms around the salad and finish with sea salt and Szechuan pepper.

1 selle de cerf d'environ 800 g

2 c. à soupe de beurre
300 g de cèpes, nettoyés et coupés en deux
2 échalotes en dés
2 gousses d'ail hachées
2 tomates pelées et coupées en dés
2 c. à soupe de persil haché
Jus de citron
Huile d'olive
Sel, poivre

450 g de roquette nettoyée et lavée
90 ml de vinaigre balsamique blanc
200 ml d'huile de noix
Sel marin
Poivre de Sichuan du moulin

Parer proprement la selle de cerf et la mettre environ 30 minutes au congélateur.
Faire fondre le beurre dans une poêle et faire sauter les cèpes avec les échalotes et l'ail. Ajouter les dés de tomate, l'huile d'olive, le jus de citron et le persil, saler et poivrer, et laisser mariner. Réserver.
Découper avec un couteau aiguisé des tranches de viande très fines. Les dresser sur une assiette badigeonner d'huile de noix. Mélanger la roquette avec le vinaigre et le reste d'huile et la placer au milieu du carpaccio. Répartir les cèpes tièdes tout autour. Rectifier l'assaisonnement avec le sel marin et le poivre de Sichuan.

1 filete de espalda de venado de 800 g aprox.

2 cucharadas de mantequilla
300 g de boletos, limpios y cortados por la mitad
2 chalotes, cortados a cuadritos
2 dientes de ajo, picados
2 tomates, pelados y cortados a cuadritos
2 cucharadas de perejil, picado
El zumo de un limón
Aceite de oliva
Sal, pimienta

450 g de rúcola, limpia y lavada
90 ml de vinagre balsámico blanco
200 ml de aceite de nueces
Sal marina
Pimienta de Szechuan del molinillo

Limpiar el filete de venado y enfriarlo durante 30 minutos aprox.
Calentar la mantequilla en una sartén y saltear los boletos con los chalotes y el ajo. Añadir los cuadritos de tomate, condimentar con sal y pimienta y marinar con aceite de oliva, zumo de limón y perejil. Poner aparte.
Cortar con un chuchillo afilado el filete de venado enfriado en rodajas muy delgadas y distribuir uniformemente en un plato pintado con aceite de nueces. Marinar la rúcola limpia con el vinagre y el resto del aceite y colocar en el centro del carpaccio. Distribuir por él los boletos tibios y refinar con la sal marina y la pimienta de Szechuan del molinillo.

1 filetto di lombo di cervo da 800 g circa

2 cucchiai di burro
300 g di porcini puliti e tagliati a metà
2 scalogni tagliati a dadini
2 spicchi d'aglio tritati
2 pomodori pelati e tagliati a dadini
2 cucchiai di prezzemolo tritato
Succo di un limone
Olio d'oliva
Sale, pepe

450 g di rucola pulita e lavata
90 ml di aceto balsamico bianco
200 ml di olio di noci
Sale marino
Frassino spinoso appena macinato

Pulite bene il filetto di cervo e mettetelo in frigorifero per ca. 30 minuti.
In una padella riscaldate il burro e fatevi saltare i funghi con gli scalogni e l'aglio. Aggiungete i dadini di pomodoro, salate e pepate e fate marinare con olio d'oliva, succo di limone e prezzemolo. Mettete da parte.
Con un coltello affilato tagliate a fette molto sottili il filetto di cervo leggermente gelato e distribuitelo uniformemente su un piatto spennellato con olio di noci. Fate marinare la rucola pulita con l'aceto e l'olio rimasto e disponetela al centro del carpaccio. Distribuite intorno i funghi tiepidi e correggete con sale marino e frassino spinoso appena macinato.

Palmenhaus

Design: Eichinger oder Knechtl | Chef: Matthias Zykan

Palmenhaus Burggarten | 1010 Wien | 1. Bezirk
Phone: +43 1 533 10 33
www.palmenhaus.at | office@palmenhaus.at
Subway: Karlsplatz, Oper
Opening hours: March–October every day 10 am to 2 am,
November–Feburary Wed–Sun 10 am to 2 am
Average price: € 20
Cuisine: Mediterran, Austrian
Special features: Breakfast, livemusic, terrace, kid-friendly

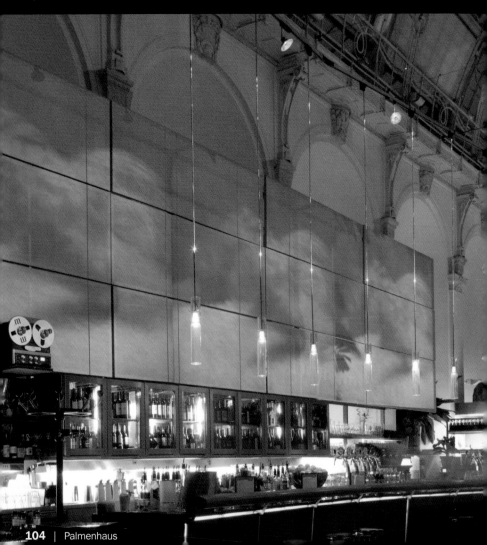

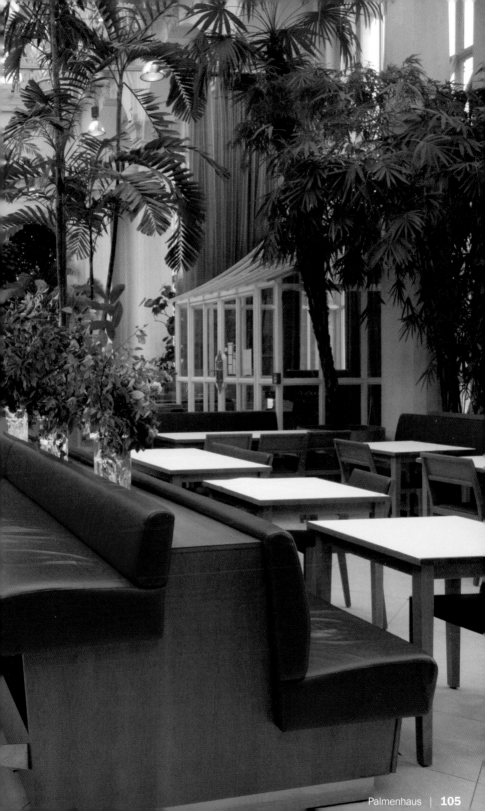

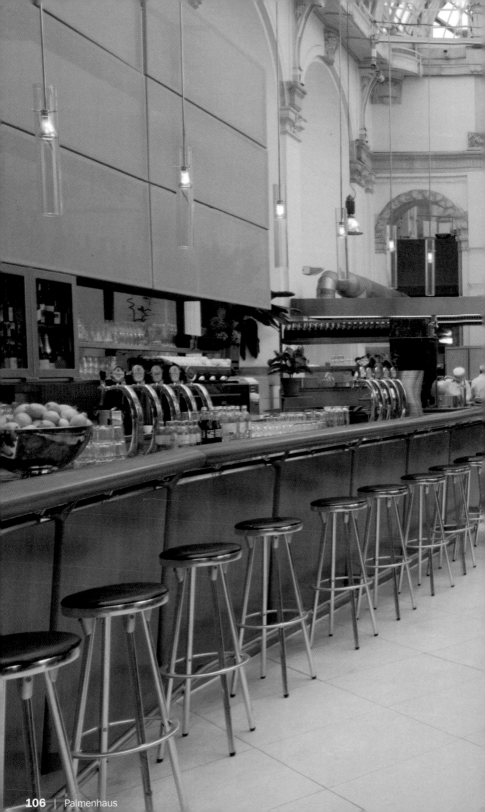

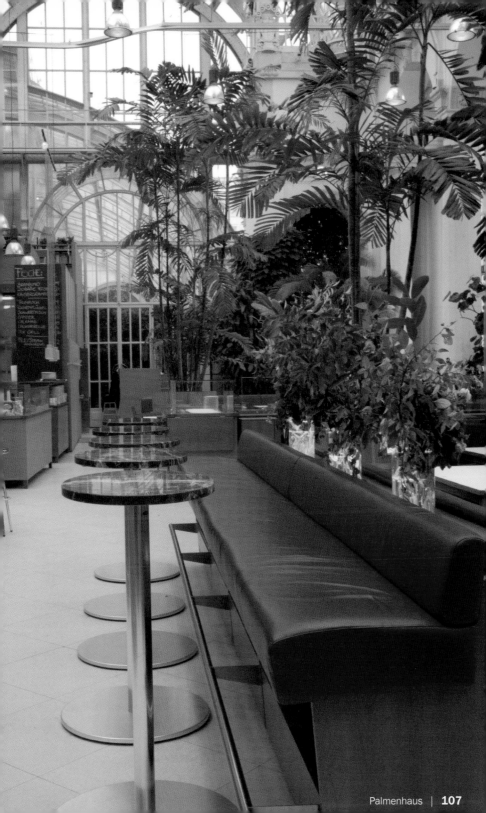

Geschmorte

Kalbsschulter

mit Hokkaidokürbis und Artischocken

Braised Veal Shoulder Piece with Hokkaido Pumpkin and Artichokes

Epaule de veau braisée avec potiron d'Hokkaido et artichauts

Pieza de espalda de ternera estofada con calabaza Hokkaido y alcachofas

Pezzo di spalla di vitello stufato con zucca hokkaido e carciofi

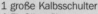

1 große Kalbsschulter
4 EL Olivenöl
Salz, Pfeffer
2 Zwiebeln, gewürfelt
1/2 Knollensellerie, gewürfelt
2 Karotten, gewürfelt
1 Selleriestange, gewürfelt
2 Sardellenfilets
Schale einer halben Zitrone
1 El Kapern
2 El Tomatenmark
1 l Rotwein
1 Hokkaidokürbis
12 kleine Artischocken
2 Quitten
Zucker
1 EL Meerrettich, gerieben

Kalbsschulter salzen, pfeffern, in etwas Olivenöl von allen Seiten scharf anbraten und in einem Schmortopf beiseite stellen. Gewürfeltes Wurzelgemüse in der gleichen Pfanne eben-falls etwas anbraten. Tomatenmark, Sardellen, Zitronenschale und Kapern dazugeben und mit dem Rotwein ablöschen. 10 Minuten köcheln lassen und zu der Schulter geben. Mit Alufolie leicht abdecken und im Backofen bei 130 °C etwa 2 Stunden schmoren lassen. Schulter in Scheiben schneiden.

Für den Quittenmeerrettich die Quitten grob zerteilen und mit ganz wenig Wasser und Zucker nach Geschmack weich dünsten. Durch ein feines Sieb passieren, etwas abkühlen lassen und mit frisch geriebenem Meerrettich abschmecken. Hokkaidokürbis gut waschen, halbieren, die Kerne mit einem Löffel herausnehmen und mit der Schale in daumendicke Spalten schneiden. Kleine Artischocken putzen und mit den Kürbisspalten in wenig Olivenöl langsam fertig braten (15 Minuten).

1 large veal shoulder
4 tbsp olive oil
Salt, pepper
2 onions, diced
1/2 celeriac, diced
2 carrots, diced
1 celery, diced
2 anchovies filets
Lemon peel of a half lemon
1 tbsp capers
2 tbsp tomato paste
1 l red wine
1 Hokkaido pumpkin
12 small artichokes
2 quinces
Sugar
1 tbsp horseradish, grounded

Season veal shoulder with salt and pepper, fry sharply from all sides in olive oil and set aside in a casserole. Fry vegetables in the same pan, add tomato paste, anchovies, lemon peel and capers and fill up with red wine. Cook for 10 minutes and pour to the shoulder. Cover with aluminium foil and braise in a 300 °F oven for about 2 hours. Cut shoulder into slices.

For the quince horseradish, cut the quinces into cubes and stew with a small amount of water and sugar until soft. Strain through a fine sieve, chill and season with freshly ground horse radish. Wash Hokkaido pumpkin, cut in half, remove the seeds and cut into evenly thin slices (with peel). Clean the small artichokes as well and fry both in olive oil until tender (15 minutes).

1 grande épaule de veau
4 c. à soupe d'huile d'olive
Sel, poivre
2 oignons en dés
1/2 bulbe de céleri en dés
2 carottes en dés
1 tige de céleri en dés
2 filets d'anchois
Zeste d'un demi citron
1 c. à soupe de câpres
2 c. à soupe de concentré de tomates
1 l de vin rouge
1 potiron d'Hokkaido
12 petits artichauts
2 coings
Sucre
1 c. à soupe de raifort râpé

Saler et poivrer l'épaule de veau et faire dorer à feu vif de tous les côtés dans un peu d'huile d'olive. Retirer la casserole du feu. Faire revenir légèrement les légumes à racines dans une poêle. Ajouter le concentré de tomates, les anchois, le zeste de citron et les câpres et mouiller avec le vin rouge. Laisser mijoter 10 minutes et mettre le tout avec la viande. Recouvrir de papier aluminium et enfourner à 130 °C environ 2 heures. Couper la viande en tranches.
Pour le raifort aux coings, couper en gros morceaux les coings, ajouter du sucre et cuire à l'étuvée dans très peu eau. Passer au tamis fin, laisser refroidir un peu et assaisonner avec du raifort frais râpé. Bien laver le potiron d'Hokkaido, le couper en deux, enlever les pépins à la cuillère et le tailler avec l'écorce en tranches de l'épaisseur d'un pouce. Nettoyer les petits artichauts. Les cuire lentement (15 minutes) avec le potiron dans un peu d'huile d'olive.

1 espalda de ternera grande
4 cucharadas de aceite de oliva
Sal, pimienta
2 cebollas, cortadas a cuadritos
1/2 nabo, cortado a cuadritos
2 zanahorias, cortadas a cuadritos
1 apio, cortado a cuadritos
2 filetes de anchoas
Piel de medio limón
1 cucharada de alcaparras
2 cucharadas de tomate concentrado
1 l de vino tinto
1 calabaza Hokkaido
12 alcachofas pequeñas
2 membrillos
Azúcar
1 cucharada de rábano picante, rallado

Poner sal y pimienta a la espalda de ternera, freír intensamente por todos los lados en un poco de aceite de oliva y poner aparte en una olla para estofar. Freír también un poco los tubérculos cortados a cuadros en la misma sartén. Añadir el tomate concentrado, las anchoas, la piel de limón y las alcaparras y rebajar con el vino tinto. Dejar hervir a fuego lento durante 10 minutos y poner con la espalda. Tapar ligeramente con papel de aluminio y asar al horno a 130 °C durante aprox. 2 horas. Cortar la espalda a rodajas.
Para el rábano picante de membrillo cortar gruesos los membrillos y rehogar al gusto con muy poca agua y azúcar hasta que estén blandos. Tamizar por un colador fino, dejar enfriar algo y sazonar con rábano recién rallado. Lavar bien la calabaza Hokkaido, cortarla por la mitad, sacar las pepitas con una cuchara y cortarla con la cáscara a trozos del grosor de un pulgar. Limpiar las alcachofas pequeñas y freír lentamente en poco aceite de oliva con los trozos de calabaza (15 minutos).

1 spalla grande di vitello
4 cucchiai di olio d'oliva
Sale, pepe
2 cipolle tagliate a dadini
1/2 sedano rapa tagliato a dadini
2 carote tagliate a dadini
1 gambo di sedano tagliato a dadini
2 filetti di acciughe
Scorza di mezzo limone
1 cucchiaio di capperi
2 cucchiai di concentrato di pomodoro
1 l di vino rosso
1 zucca hokkaido
12 carciofi piccoli
2 mele cotogne
Zucchero
1 cucchiai di rafano, grattugiato

Salate e pepate la spalla di vitello, fatela rosolare da tutti i lati in un po' di olio d'oliva e mettetela da parte in una pentola da stufato. Fate rosolare per qualche istante nella stessa padella anche la verdura a radice tagliata a dadini. Aggiungete il concentrato di pomodoro, le acciughe, la scorza di limone e i capperi e versatevi il vino rosso. Fate cuocere a fuoco lento per 10 minuti e incorporate alla spalla. Coprite leggermente con carta alluminio e fate stufare in forno per ca. 2 ore a 130 °C. Tagliate la spalla a fette.
Per il rafano alle mele cotogne tagliate le mele cotogne a pezzi approssimativi e cuocetele al vapore a piacere con pochissima acqua e zucchero. Passate con un passino fino, lasciate raffreddare un po' e insaporite con il rafano appena grattugiato. Lavate bene la zucca hokkaido, tagliatela a metà, con un cucchiaio togliete tutti i semi e tagliatela insieme alla scorza a fette dello spessore di un pollice. Pulite i carciofi piccoli e fateli friggere bene e lentamente con le fette di zucca in poco olio d'oliva (15 minuti).

Ruben's Brasserie

Design: Christoph Huber | Chef: Christian Schuster

Fürstengasse 1 | 1090 Wien | 9. Bezirk
Phone: +43 1 319 23 96 11
www.rubens.at | brasserie@rubens.at
Opening hours: Wed–Mon 9 am to 12 midnight, closed on Tuesday
Average price: € 15
Cuisine: Modern Austrian
Special features: Outdoor eating, kid-friendly

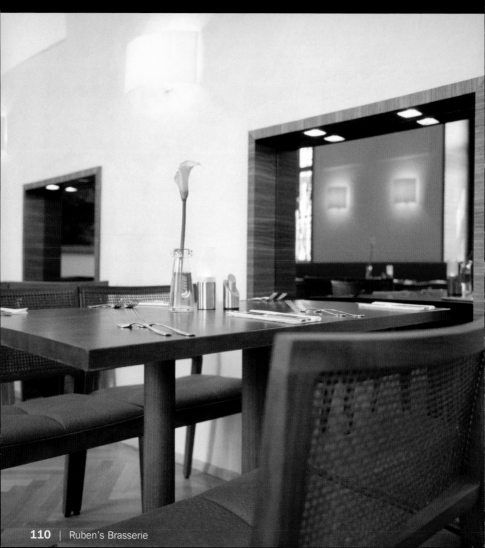

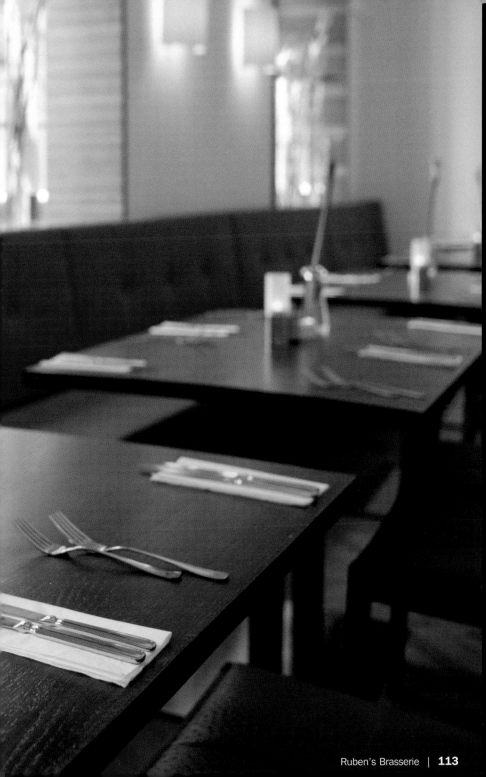

Shambala

Design: Yvonne Golds, Real Studios
Chef: Christoph Brandstätter

Opernring 13 | 1010 Wien | 1. Bezirk
Phone: +43 1 588 90 0
www.vienna.lemeridien.com | sales.vienna@lemeridien.com
Subway: Oper
Opening hours: Every day 12 noon to 12 midnight
Average price: € 25
Cuisine: Cuisine Mondiale
Special features: Candlelight Dinner, terrace, kids menu, valet parking

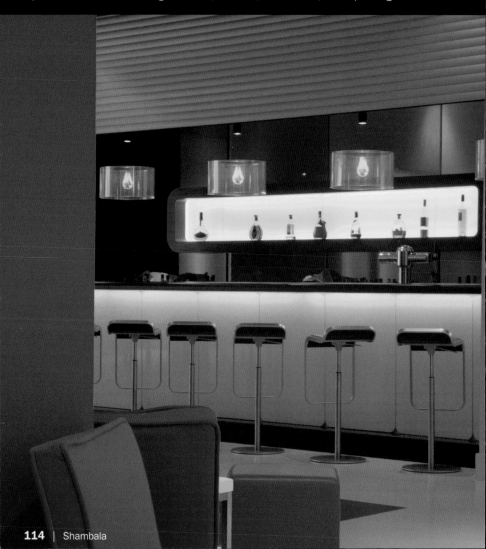

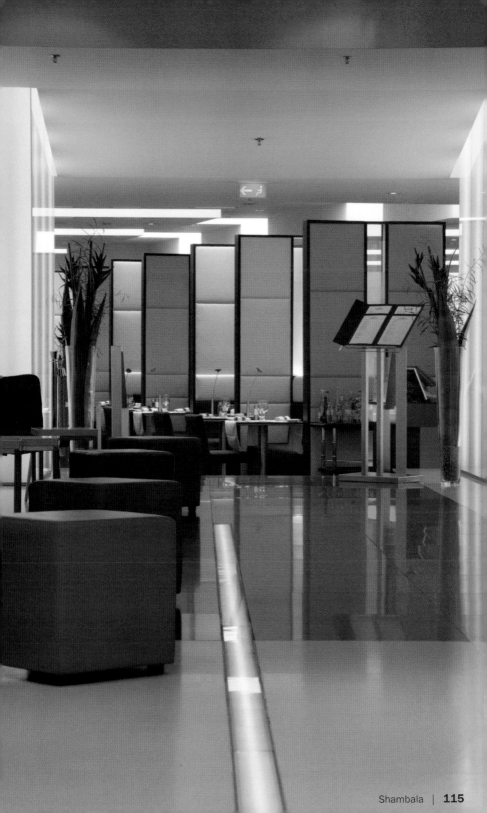

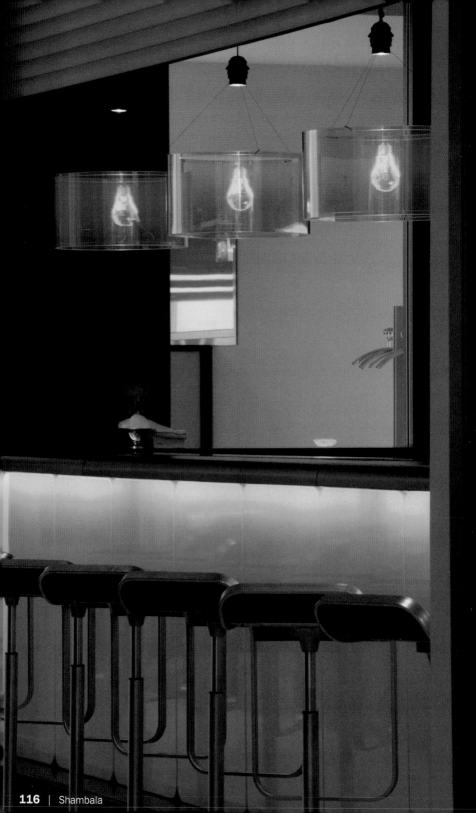

Entenbrüstchen

aus dem Grünteerauch mit Feigenconfit

Duck Breast out of the Green Tea Smoke with Fig Confit

Suprêmes de canard fumés au thé vert et confit de figue

Pechito de pato al humo del té verde con confite de higos

Petto di anatra affumicato al tè verde con confit di fichi

400 g Entenbrust

Marinade:	6 g Grüner Tee
10 g Salz	8 g Ingwer
1 Orange	1 g Lavendel
20 g Ahornsirup	2 Stängel Zitronengras

Feigenconfit:	125 ml Portwein
125 ml Rotwein	1 Stück Sternanis
1 Zimtstange	2 Nelken
1 EL Honig	4 frische Feigen
2 EL Cassispüree	

5 EL Buchenholzspäne
2 EL grüner Tee

Die Entenbrust von Sehnen befreien und auf der Hautseite mit feinen Schnitten einschneiden. Den grünen Tee mit Salz, fein geriebenem Ingwer, Schale und Saft von der Orange, fein geschnittenem Zitronengras, Lavendelblüten und dem Ahornsirup vermischen. Die Entenbrüste gut mit der Marinade einreiben und für 24 Stunden abgedeckt im Kühlschrank marinieren.

Für das Feigenconfit den Portwein und den Rotwein mit den Gewürzen um 2/3 reduzieren und danach das Cassispüree und den Honig dazugeben. Die Feigen schälen, in 3 mm dicke Scheiben schneiden und in die Reduktion einlegen. Für mind. 24 Stunden marinieren.

Die Brüste aus der Marinade nehmen und gut abtrocknen. 5 EL Buchenholzspäne und 2 EL grünen Tee in einen Topf geben, einen Teller daraufstellen, die Brüste darauflegen und den Topf mit einem gut schließenden Deckel abdecken. Den Topf bei starker Hitze ca. 10 Minuten auf dem Herd stehen lassen. Den Topf an einem Fenster öffnen, die Entenbrüste herausnehmen und warm stellen.

Die Entenbrust in sehr dünne Scheiben schneiden und zusammen mit dem Feigenconfit und etwas Salat anrichten.

14 oz duck breast

Marinade:	1/4 oz green tea leaves
3/8 oz salt	5/16 oz ginger
1 orange	1/16 oz lavender
3/4 oz maple syrup	2 stems lemon gras

Fig confit:	125 ml port
125 ml red wine	1 piece star anis
1 cinnamon stick	2 cloves
1 tbsp honey	4 fresh figs
2 tbsp cassis purèe	

5 tbsp beech wood slivers
2 tbsp green tea leaves

Remove the sinews from the duck breasts and make fine cuttings into the skin side. Mix green tea leaves with salt, chopped ginger, orange peel and juice, finely cut lemon gras and mix with lavender and maple syrup. Cover the breasts with this mixture and marinade in the fridge for 24 hours.

For the fig confit reduce porto and red wine with seasonings to about 2/3 amount, then add cassis purèe and honey. Cut figs in 1/8 inch thick slices and place in reduction. Marinade for at least 24 hours.

Remove breasts from marinade and dry off well. Put 5 tbsp beech wood slivers and 2 tbsp green tea leaves in a pot, place a plate on top of it and put breasts on the plate. Cover the pot with a tight fitting lid. Leave pot at high heat for 10 minutes on the stove. Open pot at the window, take out duck breasts and keep warm.

Cut duck breasts in very thin slices and serve with fig confit and salad.

400 g de suprêmes de canard

Marinade :	6 g de thé vert
10 g de sel	8 g de gingembre
1 orange	1 g de lavande
20 g de sirop d'érable	2 brins de citronelle

Confit de figue :	125 ml de porto
125 ml de vin rouge	1 anis étoilé
1 bâton de cannelle	2 clous de girofle
1 c. à soupe de miel	4 figues fraîches
2 c. à soupe de purée de cassis	

5 c. à soupe de copeaux de hêtre
2 c. à soupe de thé vert

Débarrasser la viande des tendons et faire de fines entailles côté peau. Mélanger le thé vert avec le sel, le gingembre finement râpé, le zeste et le jus de l'orange, la citronelle ciselée, les fleurs de lavande et le sirop d'érable. Bien enduire les suprêmes de canard avec la marinade, couvrir et laisser macérer 24 heures au réfrigérateur.

Pour le confit de figue, réduire aux 2/3 le porto et le vin rouge épicés. Ensuite, ajouter la purée de cassis et le miel. Peler les figues, découper des lamelles de 3 mm et les mettre dans la réduction de jus. Laisser mariner au moins 24 heures.

Retirer les suprêmes de la marinade et bien les sécher. Mettre 5 c. à soupe de copeaux de hêtre et 2 c. à soupe de thé vert dans une marmite, placer une assiette dessus, y déposer les suprêmes et couvrir la marmite avec un couvercle qui ferme bien. Pendant 10 minutes, chauffer à très haute température. Ouvrir la marmite près d'une fenêtre, retirer les suprêmes et les réserver au chaud. Découper la viande en très fines tranches et les dresser avec le confit de figue et un peu de salade.

400 g de pecho de pato

Marinada:	6 g de té verde
10 g de sal	8 g de jengibre
1 naranja	1 g de lavanda
20 g de jarabe de arce	2 palitos de hierba de limón

Confite de higos:	125 ml de vino de Oporto
125 ml de vino tinto	1 poco de anís estrellado
1 palo de canela	2 clavos
1 cucharada de miel	4 higos frescos
2 cucharadas de puré de cassis	

5 cucharadas de virutas de madera de haya
2 cucharadas de té verde

Quitar al pecho de pato los tendones y hacer cortes finos en la parte de la piel. Mezclar el té verde con la sal, el jengibre rallado fino, la piel y el zumo de la naranja, la hierba de limón cortada fina, los brotes de lavanda y el jarabe de arce.

Untar bien los pechos de pato con la marinada y marinar tapado en la nevera durante 24 horas.

Para el confite de higos reducir en 2/3 el vino de Oporto y el vino tinto con las especias y después añadir el puré de cassis y la miel. Pelar los higos, cortar a rodajas de 3 mm y macerar en la reducción. Marinar por lo menos durante 24 horas.

Sacar los pechos de la marinada y secar bien. Poner 5 cucharadas de virutas de madera de haya y 2 cucharadas de té verde en una olla, poner un plato encima, colocar sobre él los pechos de pato y tapar la olla con una tapadera que cierre bien fija. Dejar la olla a fuego fuerte durante 10 minutos aprox. Abrir la olla en una ventana, sacar los pechos de pato y ponerlos en lugar caliente.

Cortar el pecho de pato a rodajas muy delgadas y colocar junto con el confite de higos y algo de ensalada.

400 g di petto di anatra

Marinata:	6 g di tè verde
10 g di sale	8 g di zenzero
1 arancia	1 g di lavanda
20 g di sciroppo d'acero	2 gambi di cimbopogone

Confit di fichi:	125 ml di vino porto
125 ml di vino rosso	1 pezzo di anice stellato
1 bastoncino di cannella	2 chiodi di garofano
1 cucchiaio di miele	4 fichi freschi
2 cucchiai di purea di cassis	

5 cucchiai di trucioli di faggio
2 cucchiai di tè verde

Ripulite il petto di anatra dai tendini e incidete la pelle facendo dei tagli sottili. Mescolate il tè verde con il sale, lo zenzero grattugiato finemente, la scorza e il succo dell'arancia, il cimbopogone tagliato finemente, i fiori di lavanda e lo sciroppo d'acero. Fregate bene il petto di anatra con la marinata e lasciatelo marinare in frigorifero per 24 ore ben coperto.

Per il confit di fichi fate consumare di 2/3 il vino porto e il vino rosso con le spezie, aggiungetevi quindi la purea di cassis e il miele. Sbucciate i fichi, tagliateli a fette spesse 3 mm e metteteli nel liquido ristretto. Fate marinare per almeno 24 ore.

Togliete i petti dalla marinata e asciugateli bene. In un tegame mettete 5 cucchiai di trucioli di faggio e 2 cucchiai di tè verde, appoggiatevi sopra un piatto, adagiatevi sopra i petti e coprite con un coperchio che chiuda bene. Lasciate il tegame ca. 10 minuti sul fornello a fuoco vivo. Aprite il tegame ad una finestra, togliete i petti di anatra e metteteli in caldo.

Tagliate il petto di anatra a fette molto sottili e guarnitelo con il confit di fichi e un po' d'insalata.

Wrenkh Restaurant & Bar

Design: Eichinger oder Knechtl
Chef: Christian Wrenkh, Georg Stadthaler

Bauernmarkt 10 | 1010 Wien | 1. Bezirk
Phone: +43 1 533 15 26
www.wrenkh.at | bauernmarkt@wrenkh.at
Subway: Stephansplatz, Schwedenplatz
Opening hours: Every day 11:30 am to 11 pm
Average price: € 25
Cuisine: Vegetarian, Euro-Asian
Special features: Reservation recommended, terrace, dog-friendly, non-smoking area

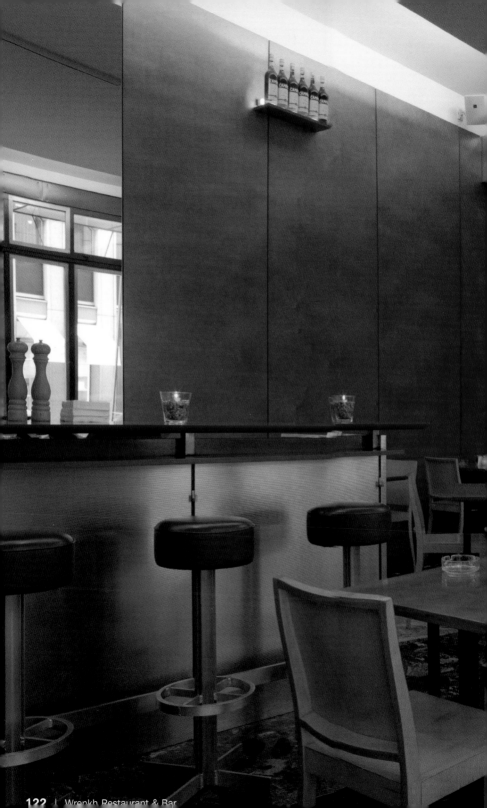

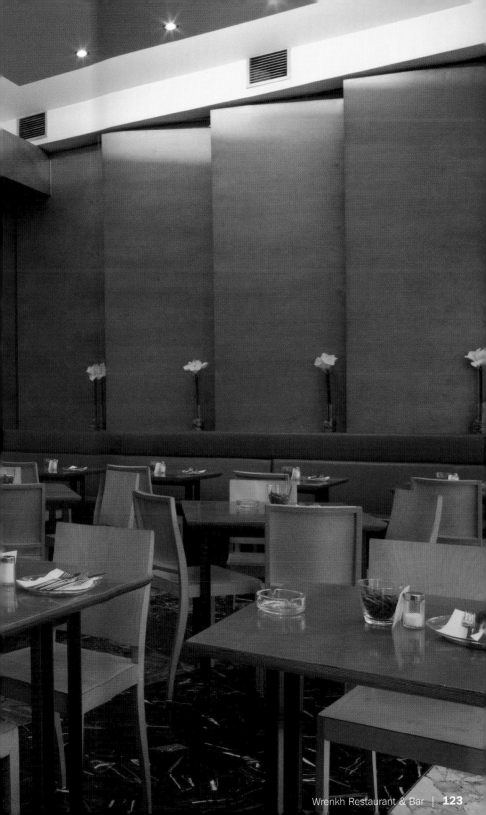

Yellow

Design: BEHF Architekten | Chef: Som Phol

Mariahilfer Straße 127 | 1060 Wien | 6. Bezirk
Phone: +43 1 595 11 55
www.yellow.co.at | mail-kontakt@yellow.co.at
Subway: Westbahnhof
Opening hours: Restaurant open every day 11 am to 12 midnight, Bar/Lounge open
every day 7 pm to 2 am
Average price: € 15
Cuisine: Thai cuisine, Japanese
Special features: Celeb scene, chill-out-lounge, unique Yellow-CDs and bags

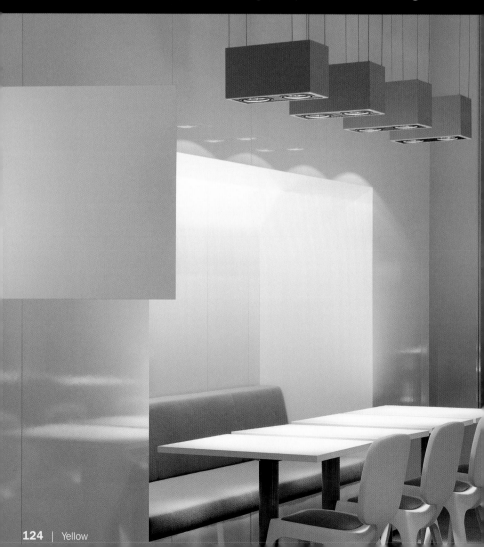

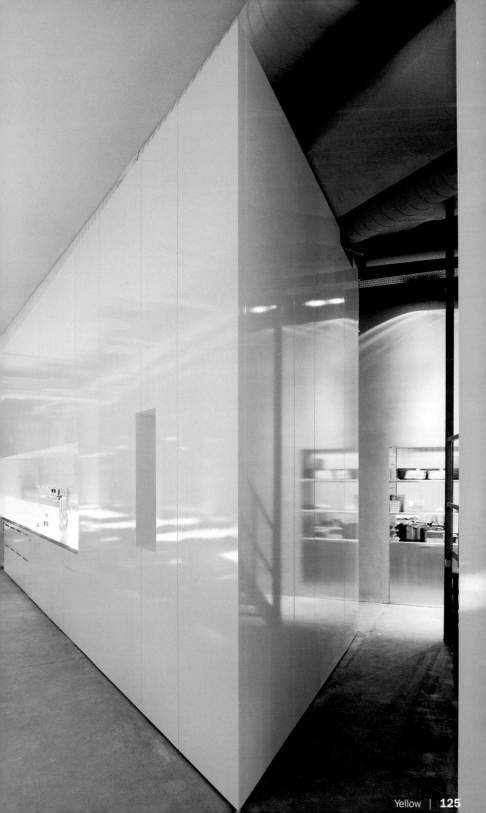

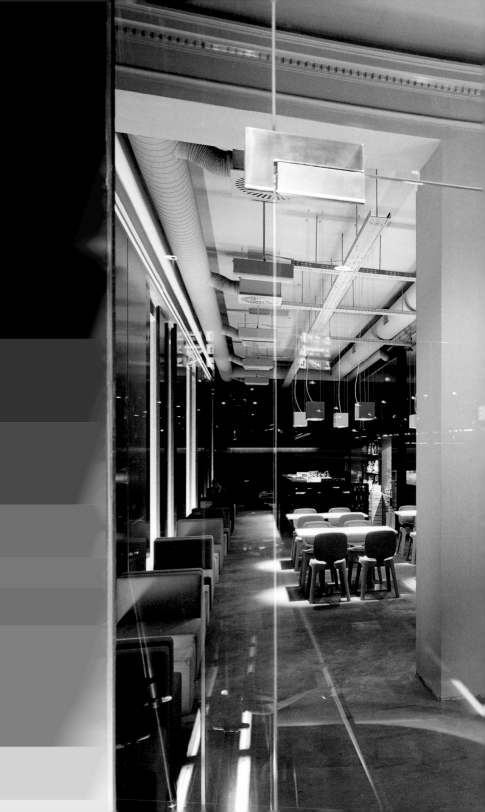

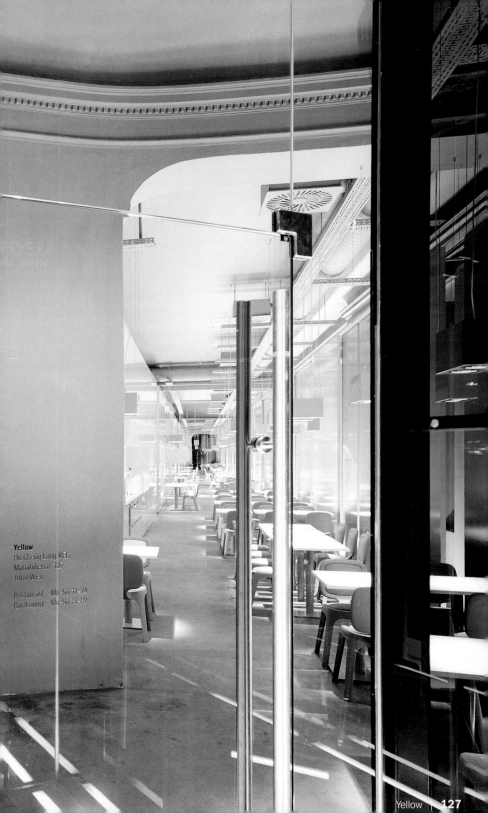

Yellow
Hu Cheng Long KEG
Margaretenstr. 127
1060 Wien

Restaurant Mo-Su 11-24
Bar/Lounge Mo-Su 19-02

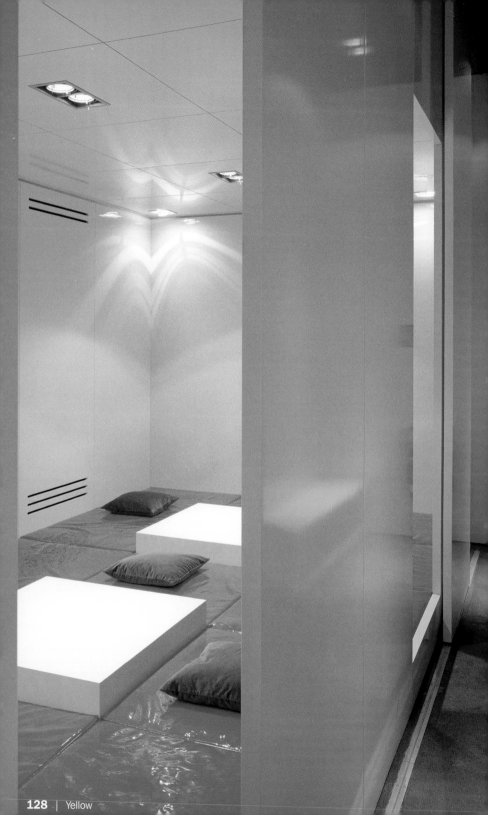

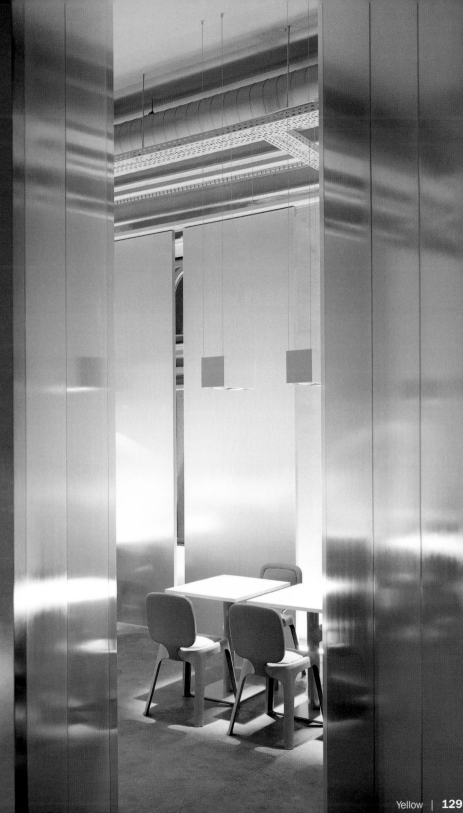

Yume

Design: BEHF Architekten | Chef: Ma Shin Lin

Bergmillergasse 3 | 1140 Wien | 14. Bezirk
Phone: +43 1 416 92 67
www.yume.at
Subway: Hütteldorf
Opening hours: Every day 11 am to 11:30 pm
Average price: € 20
Cuisine: Japanese
Special features: Take-away, private rooms, dog-friendly

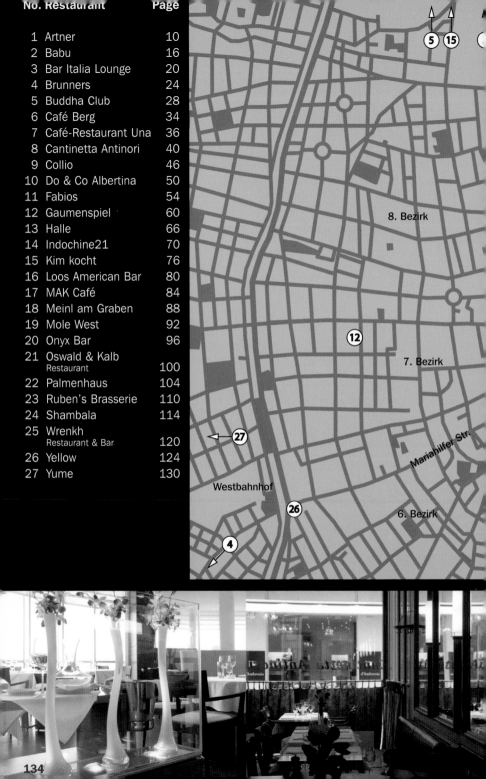

8. Bezirk

7. Bezirk

6. Bezirk

Mariahilfer Str.

Westbahnhof

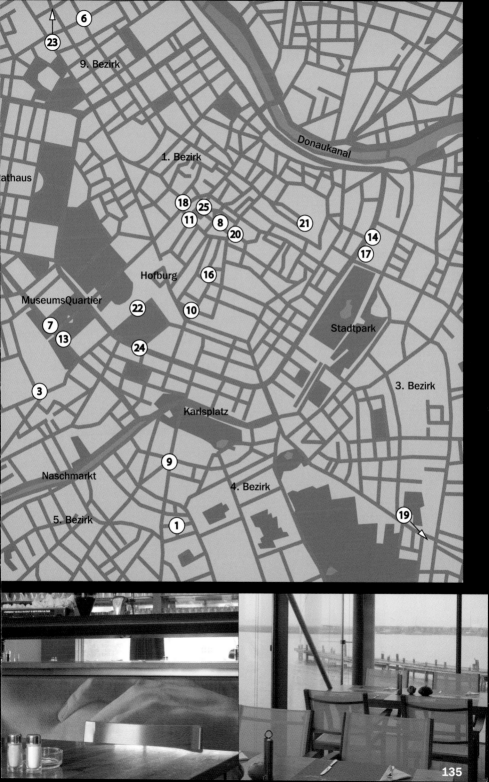

Cool Restaurants

Size: 14 x 21.5 cm / 5 $\frac{1}{2}$ x 8 $\frac{1}{2}$ in.
136 pp
Flexicover
c. 130 color photographs
Text in English, German, French,
Spanish and (*) Italian

Other titles in the same series:

Amsterdam (*)
ISBN 3-8238-4588-8

Barcelona (*)
ISBN 3-8238-4586-1

Berlin (*)
ISBN 3-8238-4585-3

Chicago (*)
ISBN 3-8327-9018-7

Côte d' Azur (*)
ISBN 3-8327-9040-3

Hamburg (*)
ISBN 3-8238-4599-3

London
ISBN 3-8238-4568-3

Los Angeles (*)
ISBN 3-8238-4589-6

Madrid (*)
ISBN 3-8327-9029-2

Milan (*)
ISBN 3-8238-4587-X

Munich (*)
ISBN 3-8327-9019-5

New York
ISBN 3-8238-4571-3

Paris
ISBN 3-8238-4570-5

Rome (*)
ISBN 3-8327-9028-4

Shanghai (*)
ISBN 3-8327-9050-0

Sydney (*)
ISBN 3-8327-9027-6

Tokyo (*)
ISBN 3-8238-4590-X

**To be published in the
same series:**

Brussels Miami
Cape Town Moscow
Geneva Stockholm
Hong Kong Zurich

teNeues